The Art of
PASTEL
PORTRAITURE

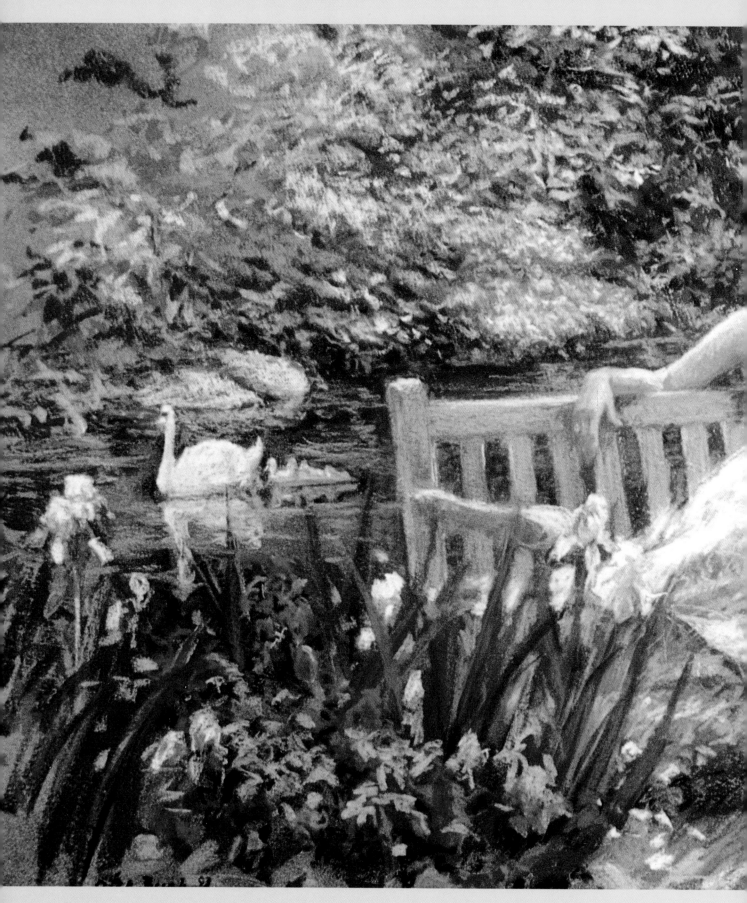

KIM
Jill Bush
Pastel on pastel canvas, 26" x 34" (66 x 86.4 cm). Collection of Mr. and Mrs. Fred Feaster.

The Art of
PASTEL
PORTRAITURE

Madlyn-Ann C. Woolwich

Watson-Guptill Publications/New York

With love and devotion to my dear husband, Joe,
with whom all things have been possible.

Acknowledgments

To all the wonderfully gifted artists in the book. Thank you for all your artistic talents, and for your willingness to go that extra mile. It was a great pleasure to work with all of you.

Many talented professional people have been very helpful in the production of this book. Thank you to the editorial and production staffs of Watson-Guptill.

To Candace Raney, Senior Acquisitions Editor, whose talent, acuity, wit, and availability were invaluable. Thank you for all the encouragement.

To manuscript editor Ginny Croft: Many thanks for the very personal way that you helped to polish the manuscript to its present form.

To Ellen Greene and the superlative Production Department. Your talents and energy are much appreciated.

To designer Jay Anning: Your inspired book designs and compelling covers always add so much to the books. Thank you for designing a dramatic and beautiful cover for *The Art of Pastel Portraiture*.

Copyright © 1996 Madlyn-Ann C. Woolwich

First published in 1996 in the United States by Watson-Guptill Publications, a division of BPI Communications, Inc., 770 Broadway, New York, NY 10003

Library of Congress Cataloging-in-Publication Data

Woolwich, Madlyn-Ann C.
 The art of pastel portraiture / Madlyn-Ann C. Woolwich.
 p. cm.
 Includes index.
 ISBN 0-8230-3906-4 (pbk.)
 1. Portrait drawing—Technique. 2. Pastel drawing—Technique.
I. Title.
NC880.W65 1996
743'.42—dc20
 96-14089
 CIP

Manufactured in China

2 3 4 5 6 7 / 02 01

Edited by Ginny Croft
Designed by Jay Anning
Graphic production by Ellen Greene
Text set in ITC Stone Serif

Contents

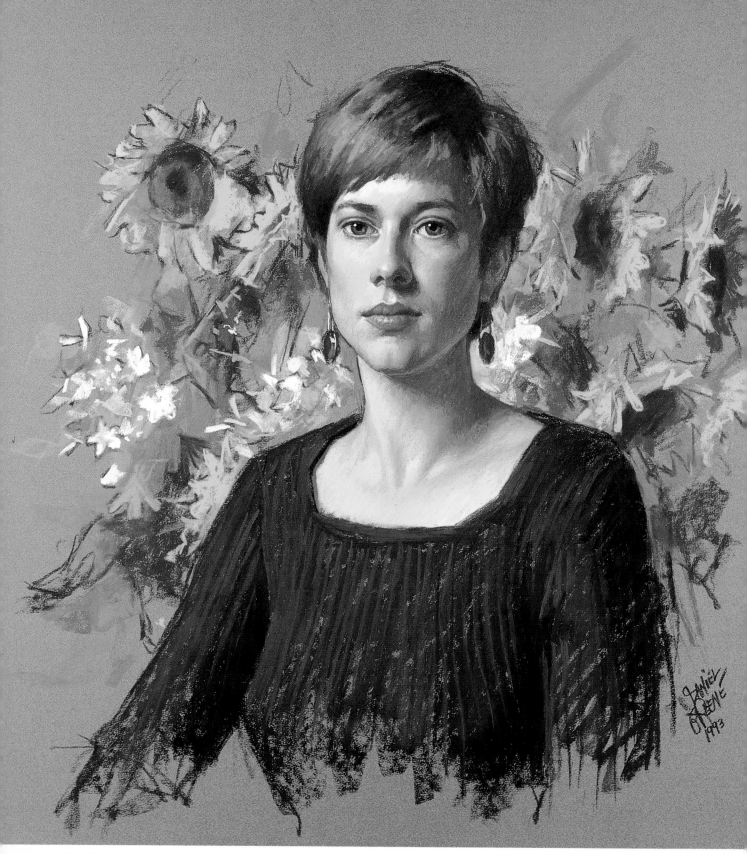

Ms. Falls
Daniel E. Greene
Pastel on Canson paper, 29" x 21" (73.7 x 53.3 cm).
Collection of Dr. Ralph Falls.

In this frontal portrait, Daniel Greene uses the natural color of the paper as a background. The light cast from the upper left bathes the face in light and casts cool shadows and warm reflections. The brightly lit sunflowers echo the focus on the face and upper torso, and the dress repeats the dark values of face and flower to create a masterful, luminous portrait.

Introduction

The field of portraiture includes both formal and informal portraits. The subjects may be shown sitting, standing, lying down, or engaged in an activity. There may be one subject or a group of two or more people. The contemporary portrait includes mood, atmosphere, and something of the contemporary world. It may capture a split second in an activity such as ice skating or dancing, a shared moment between two people, a group engaged in an occupation or hobby, or simply a person in a familiar environment. The wide latitude of portraiture ranges from loose vignette to formal full-length portrait, from a tightly rendered scene of a sailing crew in action to an impressionistic picture of a ballerina on pointe. All have their place in the lexicon of portraiture.

A successful portrait embodies the essence or character of the subject. It is familiar because it depicts what is unique in the person or persons. Additional information may be imparted by the background, clothing, or personal objects. The aim is always for naturalness and spontaneity—whether the portrait is casual or formal—with a background that compliments and lighting that emphasizes the most attractive features of the subject.

Much time and thought should be given to the placement of the subject to promote the most flattering pose and likeness. The lighting, background, clothing, and props should be coordinated so that there are bold, expressive darks, luscious midtones, bright hues of color, and beautiful light tonal values and contrasting highlights. All these component parts may be adjusted to convey the mood, personality, or character that is being presented.

The pastel medium affords the artist the use of bold, textural strokes that advance form and surface. It also can be blended and smudged to create diffused effects and soft edges. Pastel is easily corrected and/or removed from the surface of the support and therefore can be reworked without a loss of freshness. The artist can draw, correct, spray, remove, redraw, work, and rework until the portrait meets his or her expectations.

The demonstrations in this book cover such topics as composing and designing a portrait, conveying mood and emotion, working from photographs, painting multiple figures, and portraying children. Both head portraits and clothed figures are shown as they are developed and brought to a finish in an amazing number of styles and techniques. There is illustrative work, in which one part is carefully finished at a time, a step-by-step demonstration in a pointillist or impressionistic manner, and a demonstration of the rubbed and blended technique. Some portraits have a distinctly linear component; others demonstrate a plethora of carefully combined styles, all harmoniously existing in the same painting.

The book begins by covering the basics—materials, techniques, color, and composition—then moves on to more complex matters such as capturing personality and mood and painting multiple subjects. It concludes with a thought-provoking chapter in which six artists, using the same assignment directions, produce beautiful, uniquely personal pastel paintings of a female figure in a recognizable environment. By sharing their thoughts and explaining their working methods, these talented artists may inspire you to reach beyond any portrait work that you have already done. I hope that this book will help you, pique your imagination, and stretch the boundaries of contemporary portraiture.

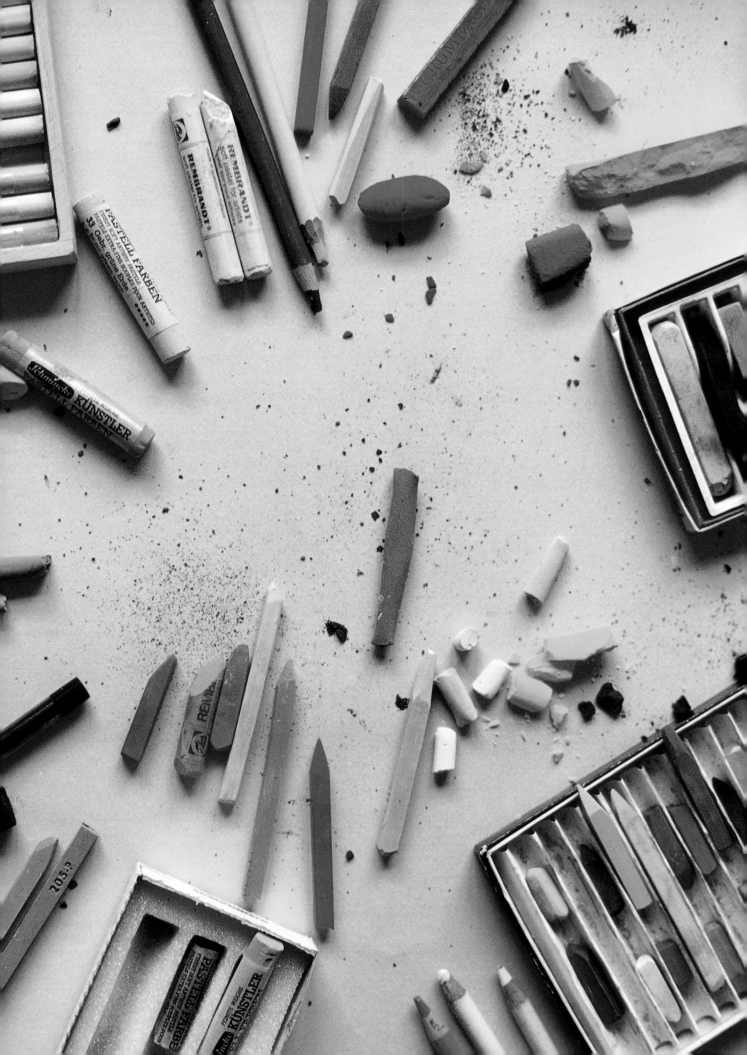

MATERIALS

Before choosing the materials you will use to make your pastel portraits, it is helpful to think about what you want your work to look like. What effects do you want to achieve? What techniques do you prefer? Which pastels and surfaces seem to suit your style and methods best?

In this chapter you will meet some artists who prefer to work in a particular technique because it expresses their individuality in the pastel medium. Like you, they are faced with a wide range of available materials, and they have chosen their materials to fulfill their artistic vision.

Pastel artists have a decided advantage over other artists: they don't need a lot of equipment. Basically, all you need are the pastels themselves, papers or other supports, and a few additional tools and materials. Once you have determined which types of pastels—hard or soft, stick or pencil—and which types of papers—smooth or rough texture, cool or warm color—suit your way of working, you are ready to equip yourself. Regardless of your preferences, always buy the best you can afford.

Pastels

Pastels come in a great variety of shapes and relative hardness or softness and range from soft sticks to hard pencils. The various manufacturers of hard pastels, such as NuPastel, Conté, and Sakura, also offer many lines of pastel pencils. Usually, but not always, hard pastels are used as the first layer in a multi-layered pastel composition. They are brightly pigmented, and their hardness makes them ideal for filling in the first layer on a granular surface. Many artists use them interchangeably with soft pastels all the way through the painting, from the first to the last layer. Easily sharpened or abraded to a point, they also are very useful for rendering the parts of portraits that need a fine, controlled stroke. There are artists who do entire portraits in pastel pencils; others use them for a feathering technique to soften and lose edges.

Soft pastels have more pigment, and their softer texture makes them ideal for various techniques. They range in softness from the recently introduced Yarka pastels, which fall somewhere between the hard and soft categories, to the medium-soft pastels from Rembrandt, Grumbacher, and Lefranc & Bourgeois, to the increasingly softer Sennelier, Schmincke, and Rowney sticks. Because soft pastels contain more pigment, the softer they are, the higher their price. There are also some handmade pastels sold commercially, such as Townsend and Arc-en-Ciel, that are truly beautiful.

Rarely does an artist stick to one brand or color or softness, and most experiment with every type of pastel on the market. When buying pastels, it's important to consider not only color and softness but also permanency and light resistance. You can find favorite colors in sets from every manufacturer, but the color names can be confusing because they often differ from standard pigment names. Pastel artists like Jonathan Bumas (whose work is shown on page 59) are urging manufacturers to give their pastels the same designations of pigment and permanence that are used for oil, watercolor, and acrylic paints.

Organizing Pastels

Pastel artists organize and store their pastels in all kinds of ways. They keep them in wooden boxes or design custom boxes to hold similar shades and tints. They store and carry them in tackle boxes, divided plastic party plates, upright boxes for nails and screws, commercial boxes, and setups that defy explanation. They may group their pastels by hue, putting all the yellows together, all the reds, and so on; by darks and lights; by temperature of warms and cools; or by brand name. What all are seeking is easy storage and portability.

Pictured on page 11 are the working setups developed by Anita Wolff, Dorothy Barta, and me to keep our pastels organized and ready for use.

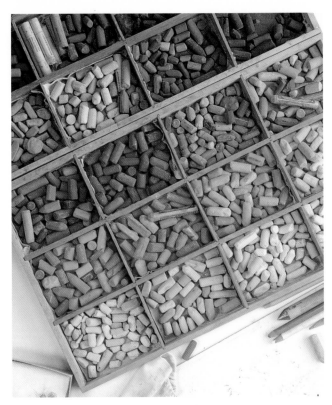

Anita Wolff's trays for separating colors.

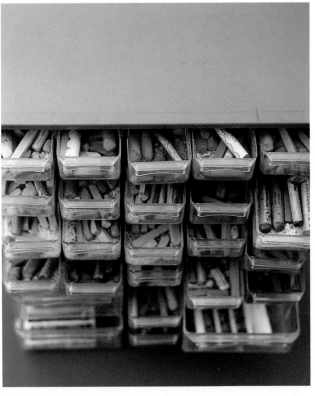

This is the chest of drawers in which I transport my pastels when I travel for workshop demonstrations.

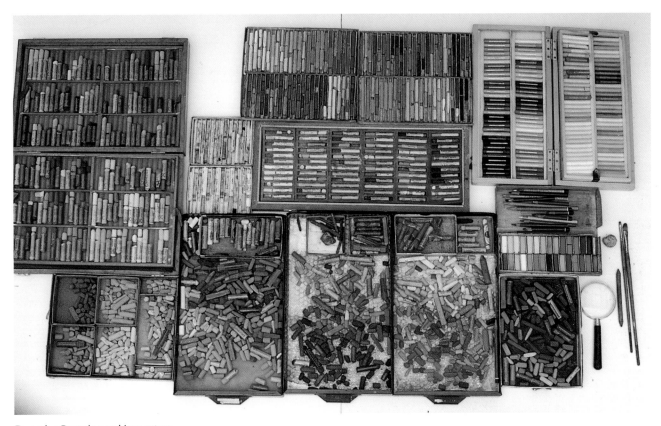

Dorothy Barta's working setup.

Supports and Surfaces

Pastel artists may use one of the many plain paper surfaces available from such manufacturers as Canson, Ingres, Strathmore, Fabriano, or Larroque. They may work on some of the commercial papers and boards that have a gritty surface. Included in this category are Ersta sanded paper in two surfaces; Pastel Deluxe Card, which has a fibrous coating; Sennelier La Carte, which has a vegetable-fiber coating; and Sabretooth, an abrasively coated Bristol board. Another choice is pastel cloth from Sennelier, an unwoven, complex surface capable of holding many layers of pastel. Pastel canvas is surfaced with a granular layer of pumice, quartz crystals, or marble dust and gesso. It is sold commercially and is also made by artists. It is usually mounted on some type of acid-free backing or stretched on wooden stretchers, much like an oil painting canvas.

Inventive artists have experimented with all kinds of self-prepared textured boards and papers.

Acid-free matboard, watercolor board, and illustration or museum board, as well as watercolor or printing paper, have been creatively utilized and coated with an acrylic/gesso/water mixture that contains one or more of the following: pumice of various degrees of roughness, marble dust, diatomaceous earth, or pyrotrol (pottery grit). Some artists use Golden acrylic's new textured surface preparation. They also create a rough surface by brushing on Res-n-gel and sprinkling some gritty substance on the surface.

The following chart shows a variety of surfaces, both commercial and homemade, that pastelists use. Each circle shows how a Sennelier pastel (left), a red Yarka pastel (middle), and a red pastel pencil (right) react to the the surface when the following techniques are used: linear, pointillist, and rubbed. Some surfaces grip the pastels better than others, with granular or fibrous surfaces showing superior ability to hold the pastel to the support.

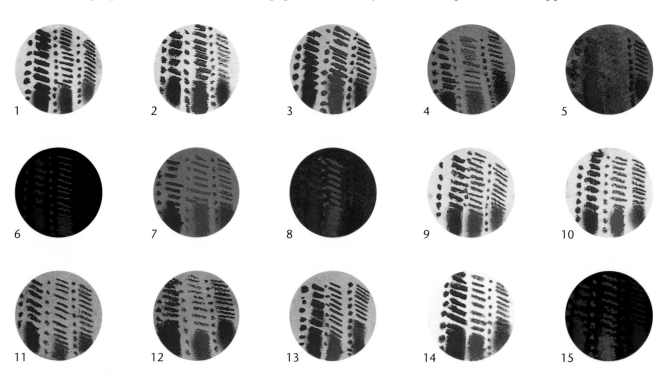

1. Res-n-gel/flour pumice/silk matboard
2. Fredrix pastel canvas
3. Ersta Starcke sanded paper (not acid-free)
4. Turquoise Canson paper
5. 3M Emory cloth (not acid-free)
6. Black Canson paper
7. Pink tinted gesso/diatomaceous earth/museum board (4-ply)
8. Norton Adelox sandpaper (not acid-free)
9. Museum board/Res-n-gel/pumice
10. Arches 140-lb. cold-press watercolor paper/gesso/pumice
11. Bienfang charcoal paper
12. Diatomaceous earth/gesso on watercolor paper
13. Sennelier La Carte pastel card
14. Pastel cloth—fibrous surface on nonwoven cloth
15. Black tinted gesso/marble dust on museum board

Preparing a Textured Surface

Although there are many ways to prepare granular board, the following sequence is one simple way to get good results. After you have mastered this method, you can use it as a jumping-off point for your own experimentation. Try different kinds of supports, various colors of gesso, and a range of gritty substances. You may experience some disasters along the way, but you may also find the perfect surface for your particular pastel technique.

Materials: The materials used to prepare the board are, from left to right, a metal straightedge, 8-ply museum rag board, (bottom) 4-ply museum board, (top) utility knife, two large house painter's brushes, stir stick, measuring cup, 1 level tablespoon of F-4 fine pumice, and Liquitex gesso.

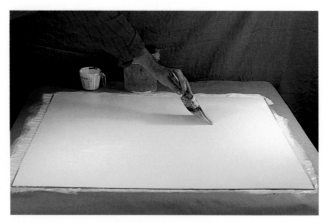

Working procedure: Mix 2½ tablespoons of the F-4 pumice into a 1-cup mixture of half gesso and half water. With a 4-inch house painter's brush, apply the mixture with random strokes to the museum board. Before each stroke, the mixture must be stirred to prevent the pumice from sinking to the bottom. For boards smaller than 40" x 32" (101.6 x 81.3 cm), the thinner 4-ply board may be used.

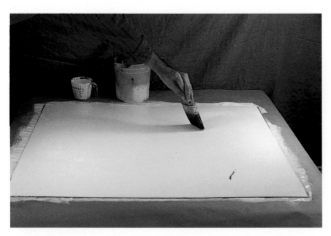

Drying: While the mixture is drying on the surface, lightly feather it with a dampened 3-inch house painter's brush. After drying, counter-prime the back of the board, either with the same pumice-gesso mixture or a half-and-half mixture of gesso and water. This prevents curling as the board is thoroughly dried.

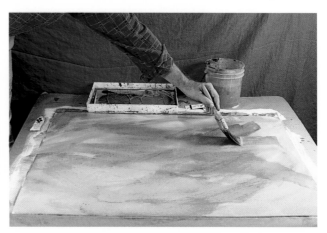

Toning: You can tone the board with a loose acrylic wash mixed with burnt umber, raw sienna, and alizarin crimson. Some artists do a complete underpainting of the subject matter with a thin wash of acrylic, watercolor, or gouache, taking care not to clog the tooth of the granular surface. To produce a darker board, use one of the new colored gessos for the pumice-gesso mixture.

Working on Various Surfaces

The same picture done on different surfaces will show subtle differences in color and texture. Some artists use the same surface for every portrait, while others constantly experiment, changing both surface and materials.

Wende Caporale paints a contemporary portrait of a young boy on pastel cloth. Claire Miller Hopkins paints a character portrait of a man on Ersta sanded pastel paper, and Marilyn Simpson, capturing a moment in time, uses a colored paper as the background for her traditional portrait of a boy.

SCUDDER
Wende Caporale
Pastel on pastel cloth, dry mounted on acid-free foamcore board, 30" x 25" (76.2 x 63.5 cm). Collection of Helen and Scudder Smith.

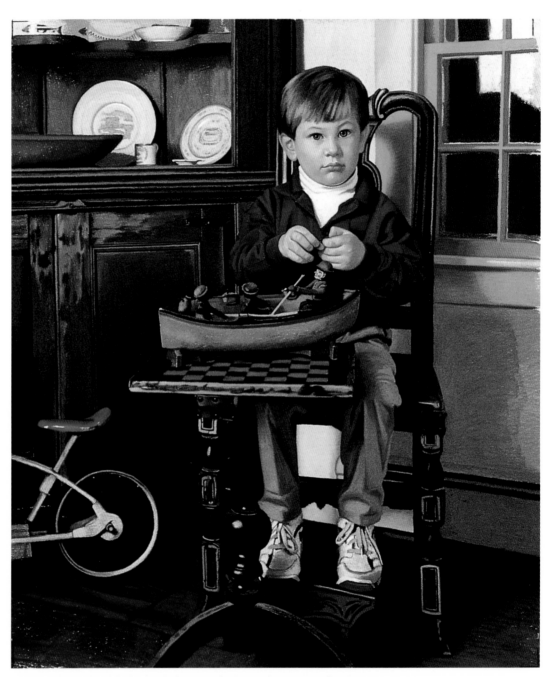

Working from life and photographs, Wende Caporale paints a glowing commissioned portrait of Scudder. Her working surface is pastel cloth mounted on acid-free foamcore and underpainted with earth tones. See adds extra texture by spraying fixative and adhering additional pumice or marble dust. "The fine sand-like tooth allows a wide range of textures." Caporale likes to work in a jigsaw-puzzle fashion, finishing one area at a time. Using an extensive palette, she emphasizes complementary colors and includes objects that are dear to the subject.

CHARLES
Claire Miller Hopkins
Pastel on Ersta sanded paper,
20" x 18" (50.8 x 45.7 cm).
Private collection.

For this vignetted head, a character study of a good friend, Claire Hopkins uses a warm palette of six or seven hues. Her surface is Ersta sanded paper, to which she applies an oil underpainting. She then works back into the wash with charcoal and additional pastels. Referring to photographs as well as the model, she draws, defines, redefines, and adds linearity at the end.

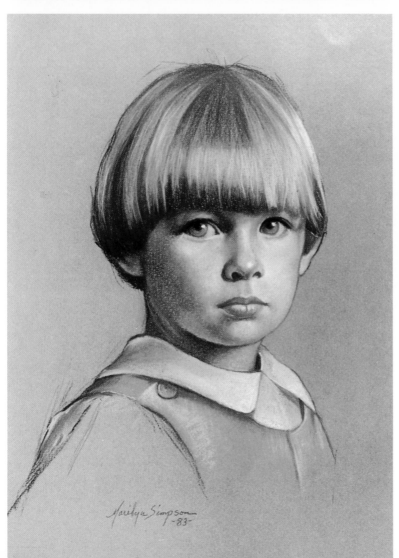

WILL
Marilyn Simpson
Pastel on paper,
25" x 19" (63.5 x 48.3 cm).
Collection of Mr. and Mrs. George C. Crew.

Will, a young boy, is done in what appears to be a simple technique. Marilyn Simpson, president of the Pastel Society of North Florida, has worked many years to attain and polish this technique. She carefully creates layers of soft pastel on tan paper and lets the color of the paper serve as the background. The head is meticulously finished, and the body shape only partially done.

Other Materials

The materials of pastel painting are fairly simple, comprising mainly pastel sticks and pencils on paper or other supports. There are, however, a few other materials and tools that are needed or useful.

Fixatives

A dilute solution of varnish is sprayed on pastel paintings to help the particles stick to the surface. Fixatives come in aerosol spray cans, which are especially handy, as well as in bottles, for application with a brush.

There are two kinds of fixative: workable and final. The first is used while the painting is in progress, to bind a layer of pastel, and the latter is used at the end to "fix" the painting. Both types darken colors and both guard against smearing. Use fixative only with good ventilation and follow the manufacturer's directions.

Solvents

Because pastels are water soluble, you can create wash effects by applying a brush dampened with water. Turpentine, mineral spirits, and isopropyl alcohol are good alternatives that dry almost immediately. In addition to wash effects, solvents can be used with a pointed brush to sharpen edges.

Paints

Both water-based paints—watercolor, gouache, acrylic, casein, and tempera—and oil-based paints can be used to create thin underpaintings for pastels. However, water-based paints should be used only on strong watercolor paper to avoid buckling. To make an acrylic wash, mix the paint with water or acrylic medium to a thin consistency. To create an oil wash, mix the paint with plenty of turpentine (never linseed oil or another slow-drying medium) to a thin consistency. Let washes dry thoroughly before working them over in pastel.

Charcoal

For sketching, you will need soft vine charcoal, which can be wiped away with a tissue. For more detailed drawings, a charcoal pencil allows extra control. With either, you may need to spray the drawing with fixative before continuing in pastel. If you want a strong, dark underdrawing that won't get lost when you paint over it in pastel, you can use black drawing ink applied with a small pointed brush.

Blending Tools

Your fingers are the handiest blending tools, but tortillons and stomps are also useful. These rigid, pencil-like cylinders are made of soft rolled paper and have pointed tips that allow you to blend and spread pastel cleanly and precisely. Other blending tools include soft rags, chamois, paper towels, and sponge brushes.

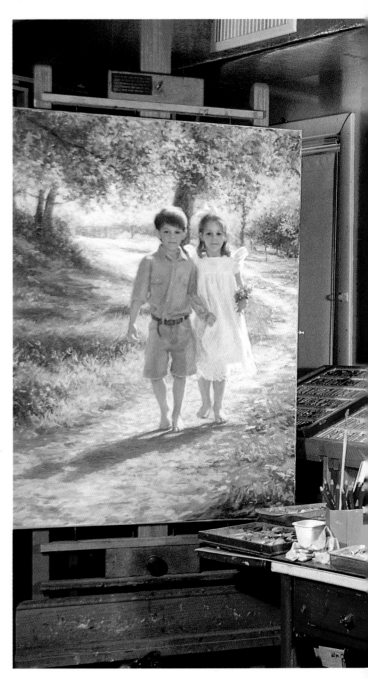

Boards and Easels

Almost any hard, even surface, such as hardboard or Plexiglas, can serve as a drawing board. The board should be large enough to hold the largest standard-size sheet of pastel paper (about 25" x 19", 63.5 x 48.3 cm) or watercolor paper (30" x 22", 76.2 x 55.9 cm) with a generous margin all around. When mounting your paper to the board, place a couple of sheets of the same size under it to provide some "give" so that the painting surface will take the pastel evenly.

For working indoors, invest in a well-made studio easel that adjusts to different-sized painting surfaces. It should adjust up and down and tilt backward and forward. For working outdoors, a folding French easel or portable aluminum easel is handy.

Jill Bush had the ultimate pastelist's taboret custom-built for her studio. It allows her to arrange her pastels according to color, hardness, or any other qualities she chooses. A work in progress is seen on her elegant large easel, and a worktable in the foreground keeps pastels in use and other tools handy.

Two

TECHNIQUES

Many artists consider pastel the most versatile painting medium, perhaps because of the fact that it uses drawing as well as painting techniques. It can be manipulated with blending tools, a knife or razor blade, erasers, and solvents and combined with other media to create an endless range of effects. The texture of the paper or other surface affects the look, as well as the types of strokes used to apply the pastel. Whether the approach is linear or more painterly, pastel has an expressive potential unmatched by any other medium.

To exploit that expressive potential, it is essential that you master the full range of pastel techniques. From such basics as linear strokes (the closest to drawing) and side strokes (using the side of the stick) to the fine points of blending to create areas of color and soften edges to more advanced application methods like scumbling, feathering, and dusting—the techniques of pastel offer the artist a range of tools for creating any effect that is desired.

AT THE MARKET
Marbo Barnard
Pastel on paper,
28" x 22" (71.1 x 55.9 cm).
Collection of the artist.

Application Methods

Artists use multiple techniques, often within the same pastel painting. It is not unusual for the background of a portrait to be done with the pastel stroked on its side and overlaid with diagonal strokes. Sometimes the subject is painted with a combination of the following techniques: an underpainting is applied with either oil stick or oil and turpentine, pastel and turpentine, watercolor or gouache, then the pastel is built up in a painterly manner, with parts done in a rubbed technique or with stroked, dotted, or crosshatched lines in an impressionistic or pointillist manner.

Depending on your personal preference, you can use one or more of the following techniques for your subject and background: impressionistic, using small strokes or dots; painterly, using the flat of the pastel and building layers, as you would do in an oil painting; blended, in which every color and value is rubbed and ameliorated, and the edges made all but imperceptible; and linear, in which the drawing is stated and restated throughout the composition and remains an important part of the finished picture. Something must be said for those talented pastelists who use a combination of these methods in the same painting.

How do you hold pastels for the kind of strokes that are needed? To make linear strokes, apply the pastel with the tip of the stick. If you are using soft pastels, you will produce a thick line, whereas with hard pastels and pastel pencils you will produce thin lines. The lines can be hatched, or parallel, or crosshatched, crossing each other. For areas of color, you can use side strokes, which are made by holding the pastel stick on its side against the paper. Lightly applied side strokes reveal the texture of the surface, whereas heavier strokes produce a blanket of smooth, dense color.

Blending can be used to soften edges and lets you mix colors placed next to each other to create new hues or a gradation of color. You can use your finger or a tortillon, stomp, or small brush for blending. For a large area, rags, chamois, and tissues work well. Scumbling is done by dragging one color over another without covering up the first color, and feathering involves stroking one color over another in thin parallel lines. Dusting creates a soft haze of color; hold a pastel stick over the painting and scrape or sand it to deposit a fine shower of colored particles in the desired area.

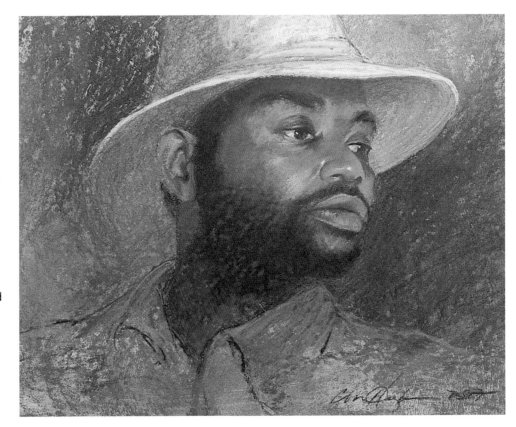

JIMI
Claire Miller Hopkins
Pastel on sanded paper,
15" x 19" (38 x 48.3 cm).
Collection of the artist.

With the exception of the features, most of Jimi's portrait contains varied strokes that define the different textures of the composition. The background of dark green moves into the shadowed beard and makes linear accents in the shirt. The greens of the beard complement the reddish-brown tones of Jimi's skin. Facial areas are delicately etched with small hatched and crosshatched strokes.

ASPECTS OF ANN
Claire Miller Hopkins
Pastel on Ersta sanded paper,
22" x 27" (55.9 x 68.6 cm).
Private collection.

Commenting on this example of her character portraits, Claire Hopkins says, "Because I find the model's face very interesting, I want to present more than one point of view." There are multiple heads in the picture, all sketched with charcoal pencil, and the images are built up with diagonal strokes. The background wash of blue and burnt sienna is scrubbed in with an old brush and turpentine. Hopkins's palette includes raw sienna, blue-green, raw umber, charcoal, and red in four or five values. The detail below shows Hopkins's use of hatched strokes.

DAY LILIES
Marilyn Simpson
Pastel on paper, 24" x 19"
(61 x 48.3 cm).
Collection of the artist.

Simpson paints a shadowed meadow with a slender woman gathering flowers. The long dress moves, folds, and captures the light. Vertical strokes indicate the direction of grass growth, and small, dotted strokes make up the field of wildflowers and shadowed trees. The luminous raking light strengthens the contrasting yellow-orange basket against the complementary color of the blue dress.

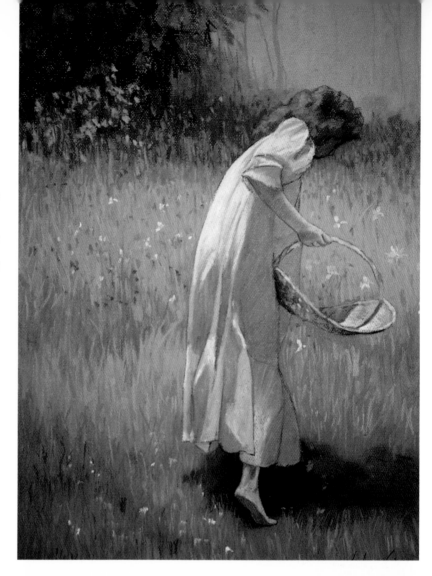

BRITTANY AND MARY ELLEN
Jill Bush
Pastel on canvas, 29½" x 26"
(74.9 x 66 cm).
Collection of Dr. and Mrs. Michael Stanley.

This sun-drenched portrait of a mother reading to her daughter in the garden shows strong directional strokes from the upper right to the lower left, which add rhythm and movement to the color and light. The mood of this peaceful, sunny portrait is one of tranquility and peace, in which a loving mother and her child are serene in the moment. Small slanting strokes bring light to the shrubbery behind the mother and direct the viewer's attention to the faces of both mother and daughter. The impressionistic strokes and dots add texture and direction to the portrait.

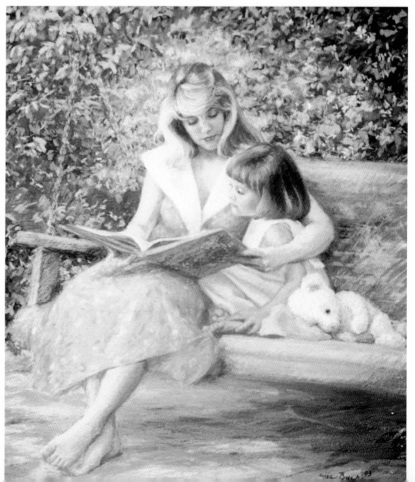

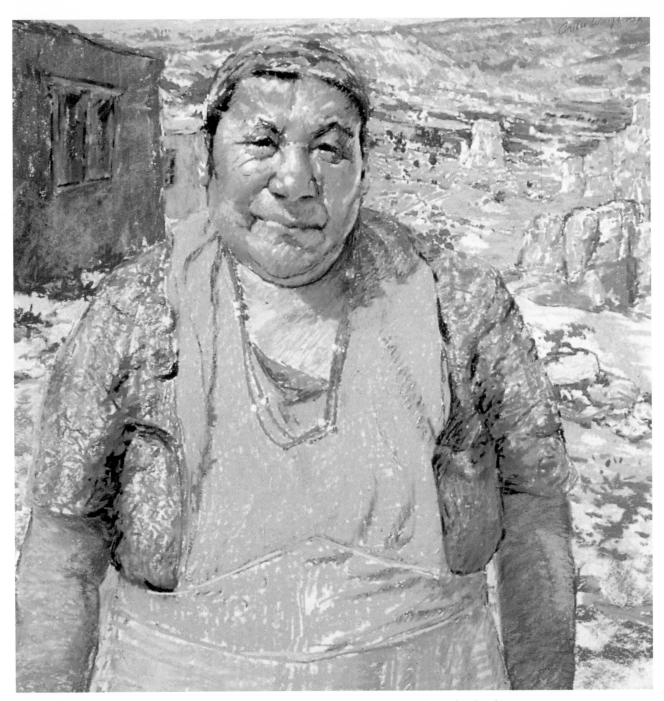

Juana
Anita Wolff
Pastel on paper, 30" x 30"
(76.2 x 76.2 cm).
Collection of the artist.

Juana is a character portrait of a Mexican woman dressed in bright clothing, rendered with small, close strokes of color. Her seamed face in reddish-brown tones is a strong complementary contrast to the cool greens and blues of the background.

Using a Variety of Strokes

In the demonstration that follows, Jill Bush utilizes several visible and notable application techniques:

1. Crosshatching—crossing one color over another using linear strokes—in the faces.

2. Broad lay-in, especially in the background areas, where the broad, flat side of the pastel is used to mass in or establish a large, negative shape.

3. Blending—judiciously softening areas or edges with a tortillon or the pinkie finger, using a light touch so as not to muddy the pastel and lose its freshness.

4. Glazing—using pencils to veil an area with another color, good for subtle changes. Hard pastels are also good for this.

5. Softening edges by merging two color areas with a third color (hard pastel or pastel pencil), creating a mid-hue between the two areas. Note how Bush softly works dark blue-green into the hair and background edges to unify and lose edges. The dark blue-green is the split complement of the orange-reds (burnt umbers and siennas) of the hair and the violets of the background and creates a mid-hue to merge the two areas.

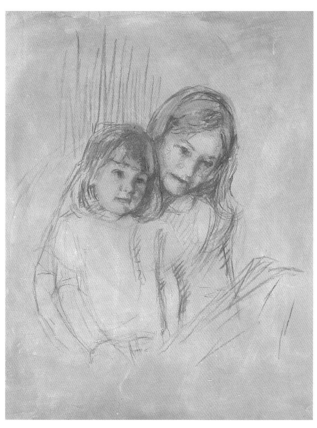

Step 1: "After measuring for position," Bush explains, "I use charcoal to carefully place the heads of the mother and child on the sanded board. I begin gesturally and work from the 'touching edges' into both heads and across both forms. The placement and relationship are most important."

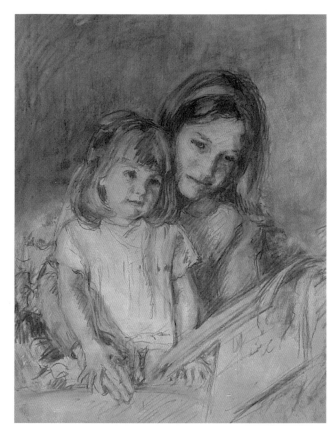

Step 2: "I further develop the figures, working gesturally with line and mass. The drawing has solved most of the inherent problems of pattern, composition, value, gesture, spirit, and likeness."

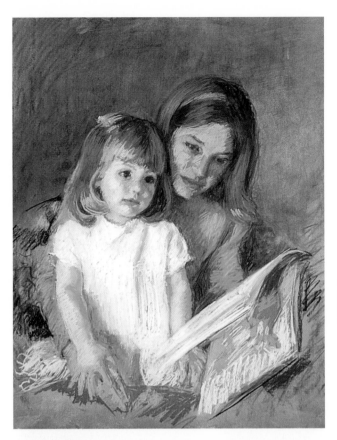

Step 3: "I select the palette and begin the flesh tones, using soft pastels, pastel pencils, and some of my homemade pastels. I develop the mother's face and clothing and strengthen the pattern on the chair."

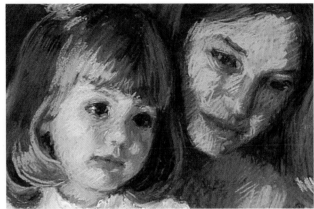

Step 4: "My crosshatching technique is shown in two stages. The mother's face is shown in the first stage, and the child's face in the second stage."

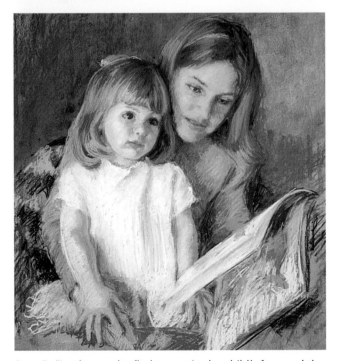

Step 5: "I enhance the flesh tones in the child's face and the lights in the mother's face. I correct the mother's hands. Next, the somewhat grayed tones of English red, caput mortuum, and gold and flesh ochres are used for middle tones. The cross strokes are done with green ochres into the red tones to give dimension to the forms."

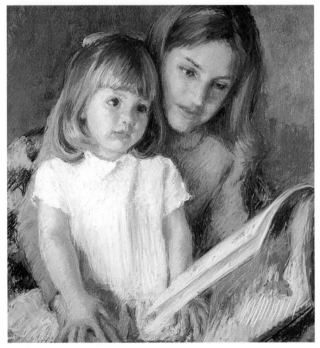

Step 6: "This color and transition stage is an energetic one in which the development of color and edges is of paramount importance. Colors are further stroked, and the background is changed by extending the floral back of the chair. Colors are intensified and edges are strengthened or softened for a pattern of lost and found that imparts a finished appearance to the portrait."

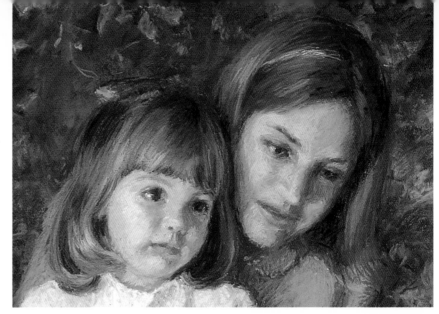

Step 7: "The finished portrait shows the warm reds and pansy violets for color modification. The final touches are done by dragging Yarka blue-violets over areas of the background for refinement."

MOTHER AND CHILD
Jill Bush
Pastel on sanded board,
22½" x 18½"
(57.2 x 47 cm).
Private collection.

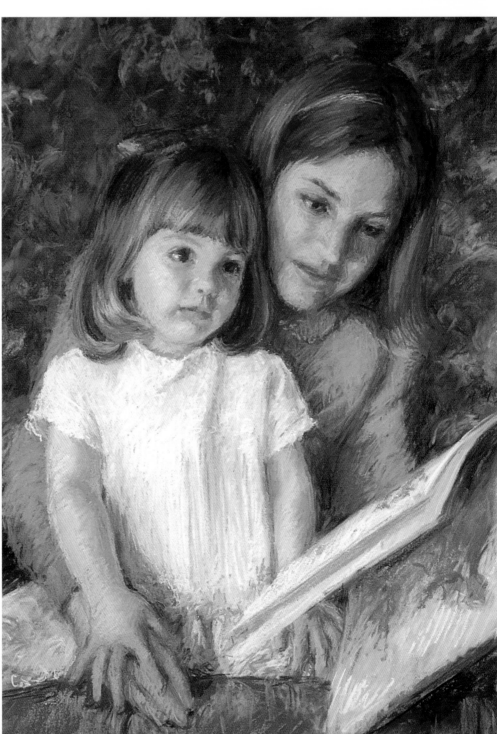

Keeping Surface Texture Interesting

Jim Promessi employs a layering technique, working from dark to light, to create a simple composition using the entire figure. "Because I wanted to capture John's likeness," he explains, "I planned a plain, simple, light background so that his relatively dark figure would be somewhat silhouetted. I work from dark to light using the broad side and the point of the stick to apply the pastel. When stumping [blending] for a base color, I use an open stroke over it to let the background show through. This creates a surface that is not flat, smooth, or monotonous."

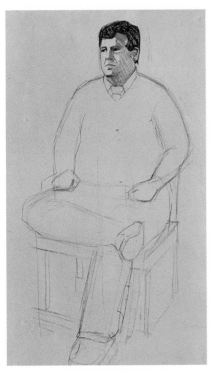 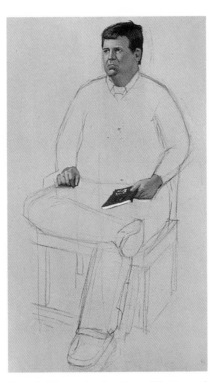 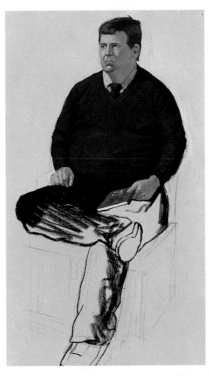

Step 1: Promessi carefully places the initial drawing on Sennelier La Carte pastel card and begins the application of color.

Step 2: The major families of lights and darks are massed in the hands (siennas, umbers, cadmium reds, ochres and flesh ochres, blue-greens). The color application is developed, and the head and hands are brought to a near finish. Slight adjustments will continue throughout the picture. The red book is used as a color accent.

Step 3: The rest of the figure is laid in similarly, stroking from dark to light and from the general to the particular or from simple to complex forms.

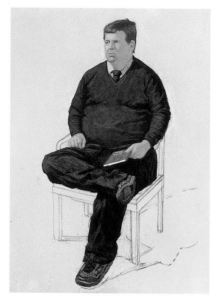

Step 4: With the figure nearly completed, all the lights and darks will be applied at the end. The chair, cast shadow, and the background are now filled in to complete the pastel.

Step 5: This detail reveals how Promessi layers pastels, working from dark to light and going from the simple to the complex.

Step 6: Nearing the end, all the final decisions are made and finishing touches and corrections are integrated into the composition.

JOHN
James Promessi
Pastel on Sennelier
La Carte pastel card,
26" x 19" (66 x 48.3 cm).
Collection of the artist.

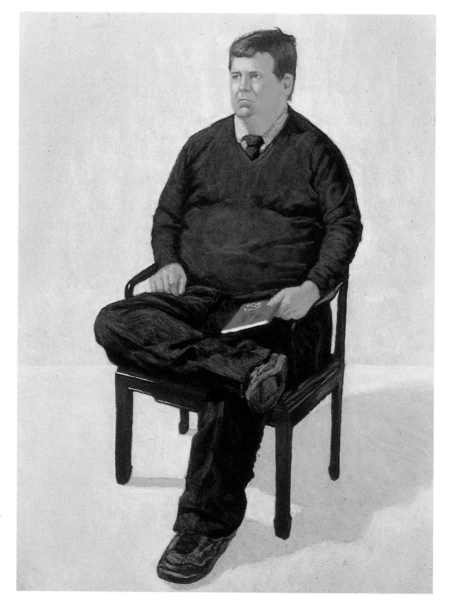

Working with Preparatory and Preliminary Sketches

Artists prepare surfaces and approach their pastel paintings in a number of different ways. Sketching with NuPastel or charcoal, using photographs, and working on a surface purposely abstracted are but a few of the creative ways that artists place and prime their initial sketches.

Transferring a Drawing

Anita Wolff paints *Tahitian Lady* from a photograph taken during her travels to the South Pacific. After establishing the preliminary drawing, she decides to do a separate contour drawing to work out the position of the head and hands. She then uses tracing paper to transfer the drawing to her painting surface, as described in the following demonstration.

Wolff uses techniques that are impressionistic in style, with small strokes of color. She says, "I start with an underpainting of lightly applied pastel, working from dark to light values, which are done with soft pastel."

Step 1: "Using red Conté crayon," Wolff begins, "I complete the preliminary drawing on ivy-colored Canson paper. The value of this color is dark and will create a striking effect when the light colors and the red dress are placed."

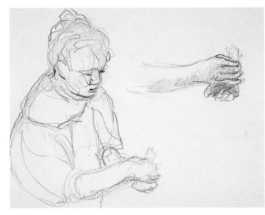

Step 2: "I need to do a contour drawing to understand the position of the hand and the tilt of the head. I draw with a number-6 Venus pencil on Bristol board."

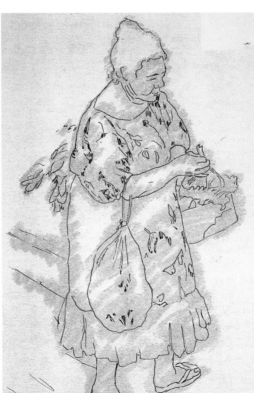

Step 3: "I redraw the figure on tracing paper, and on the reverse side I draw red Conté crayon over the lines. Then I place the tracing paper over the ivy Canson paper and retrace the lines to transfer the drawing to the paper."

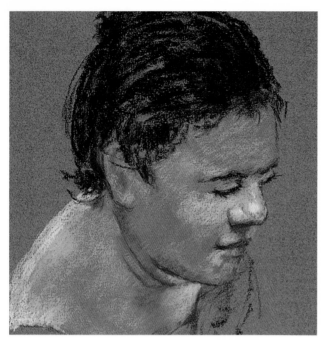

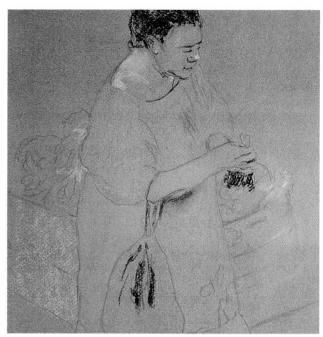

Step 4: "The development of the head begins with a drawing of red Conté crayon, which I apply over the features. Ivory black is used for the hair. Highlights are added and the drawing strengthened with sepia. Vermilion defines the shoulder area, and poppy red is used for the dress. As colors are added, some paper is allowed to show through."

Step 5: "The transfer lines of the figure can still be seen at this point, and I reestablish the lines and darken them."

Step 6: "I begin to add local color, flesh tones, and black for the hair, purse, and satchel. Patterns are begun on the dress with exotic and bright colors."

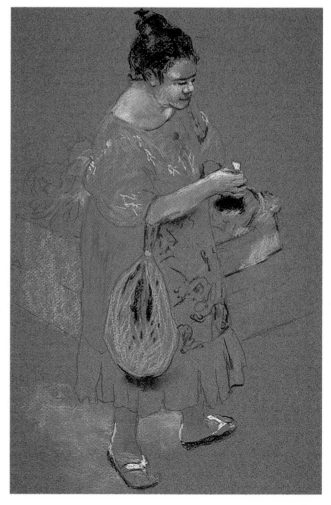

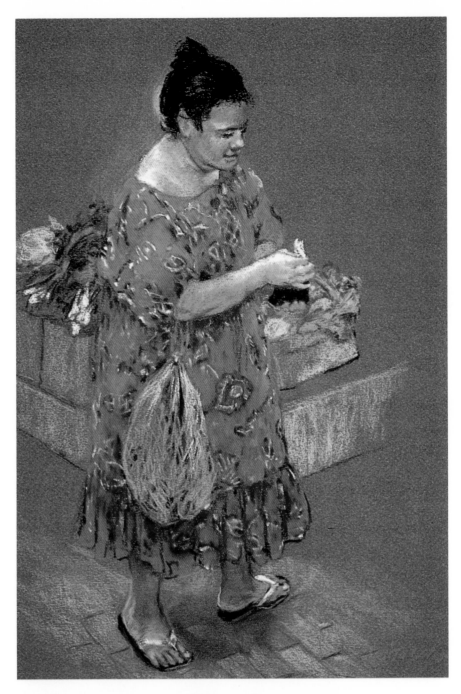

Step 7: "Final touches are added to the clothing, plus a little detail of bricks and baskets of produce. I use warm grays for highlights on the arms, feet, and shoulders. I work to simplify the pattern and keep the attention on the face."

TAHITIAN LADY
Anita Wolff
Pastel on paper, 16" x 12" (40.6 x 30.5 cm). Collection of the artist.

Color chart for *Tahitian Lady:* All pastels are by Rowney except for the three greens, which are NuPastel.

Using a Color Thumbnail

Doug Dawson, a Colorado artist, begins his portrait with a loose gestural thumbnail sketch in pastel to catch the contour of the model, decide on the palette, and work out the spatial divisions of a young woman by lamplight. It serves as a color study that he will refer to throughout the pastel portrait.

Step 1: "On paper, I create a color thumbnail sketch," Dawson says, "to make preliminary decisions about color, space, and gesture."

Step 2: "On pastel card, I begin with four pastels and pick colors with three different values. Blocking in large shapes, I draw a midline through the head, neck, and torso to establish the rotation angle of the body. Then I locate the eyes, nose, and bottom of the lower lip. Because I am looking up, the eye line is higher than the middle of the face."

Step 3: "Thinking of head and hands as large shapes, I divide them into large light and shadow sides. The shadows are done with the darker shade, which I use to block in the light side of the hair."

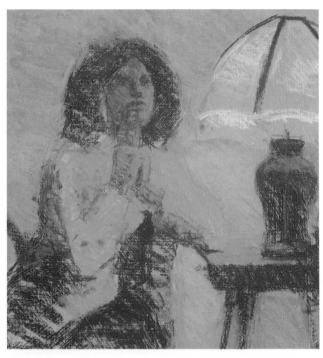

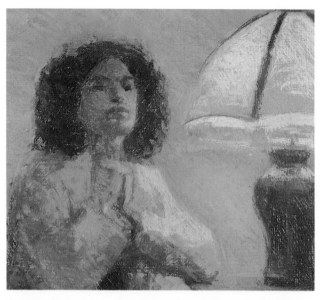

Step 4: "I continue to break up large shapes into small shapes by the edge of the table and the top of the skirt. The lampshade is divided into light and dark. The contrast in the face colors is also developed."

Step 5: "To add drama, I change the angle of the head a little and rework the features. The whites of the eyes are indicated when everything else is satisfactory. The background gains more violets as it recedes from the lamp. Lightening the lampshade to show radiation, I also add lights to the lightest side of the face. The bright spots of the pastel support are refined and covered with more pastel to sustain a more polished look.

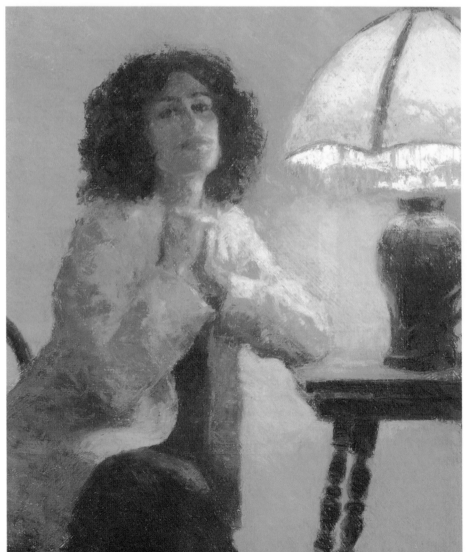

Susan by the Lamp
Doug Dawson
Pastel on La Carte pastel card,
24" x 20" (61 x 50.8 cm).
Private collection.

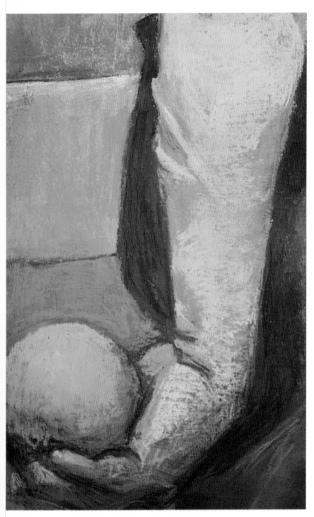

Step 5: "This detail shows the modeling and strokes of the hand and arm."

Step 6: "To finish, I add a few touches to the pit, the socks of the older man, and the trees. The cap gets purple shadows, and dark tans and light greens are placed on the brim. I reflect reds into the T-shirt and add small touches to the shoes to complete the picture."

THE KISS
Alexander Piccirillo
Pastel on sanded illustration board,
60" x 40" (152.4 x 101.6 cm).
Collection of the artist.

Starting with an Abstract Underpainting

Dorothy Barta, borrowing from Charu Shah's artwork, uses an abstract underpainting to create a character background for her pastel and turpentine painting of the artist. Working on Ersta sanded paper, she begins the sketch with charcoal.

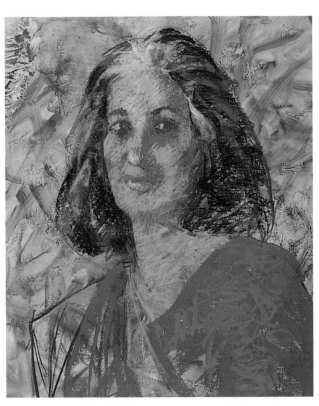

Step 1: "In random fashion I apply pastels on Ersta sanded pastel paper," Barta notes. "Then I wash the lines with a bath of Turpenoid, using a 2-inch flat brush. The charcoal drawing is placed on this surface."

Step 2: "I put in the first layer of pastel in broad strokes, defining shadow areas and middle values."

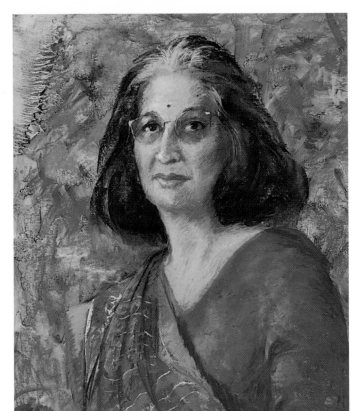

Step 3: "Completing the final pastel layer with all facial features well defined, I finish the pattern on the face."

HEAD OF CHARU SHAH
Dorothy Barta
Pastel on sanded paper,
24" x 18" (61 x 45.7 cm).
Private collection.

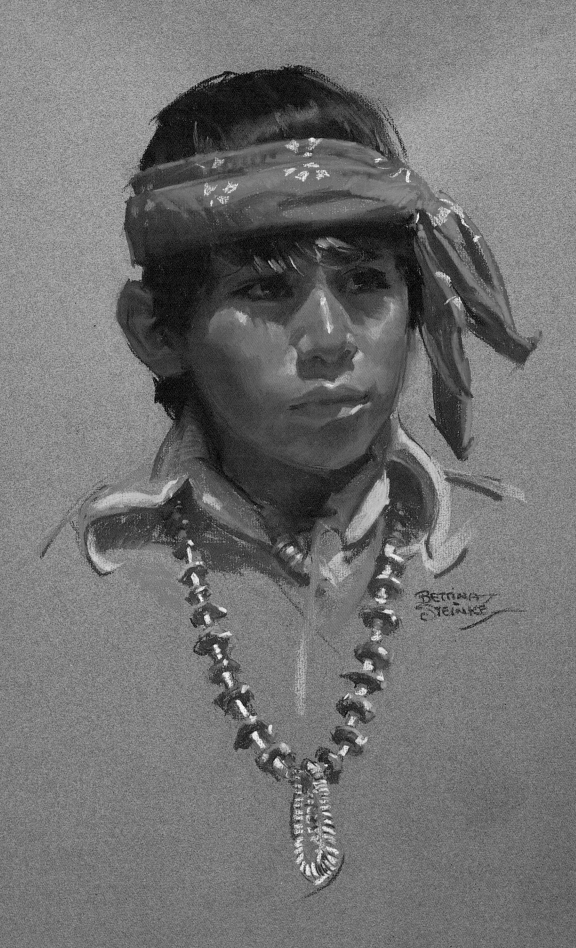

COLOR

No medium is as well known for its vibrant hues as pastel. Because color mixing is done on the surface of the painting, not on a palette, pastel sticks and pencils come in an amazing range of colors, with every manufacturer striving to supply the artist's needs. With so much to choose from, it is especially important that the pastel artist understand the fundamentals of color.

For that reason, this chapter begins by clarifying the vocabulary of color, then covers the important topics of choosing your pastels and working with different kinds of palettes. In a particularly enlightening exercise, Greg Biolchini shows how the same subject looks when painted with a high-key, low-key, and unlimited palette. Other portraits illustrate the use of a primary triad and the effects of analogous and complementary colors.

INDIAN BOY
Bettina Steinke
Pastel on paper,
24" x 19" (61 x 48.3 cm).
Private collection.

Using a Limited Palette

Greg Biolchini, using a limited palette composed of hard NuPastels and soft Rembrandt pastels, creates a beautiful effect and captures a moment of joy. The beige of the Canson paper acts as the main middle value, which Biolchini uses as the basis for all the light, middle, and dark values in the portrait.

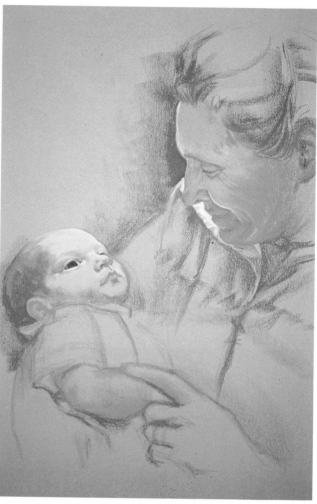

Step 1: "I start this portrait with sharpened cocoa brown and burnt umber NuPastel on Canson paper," notes Biolchini. "I use NuPastels for the drawing stage because they hold a point better than soft pastels for producing a sharper line."

Step 2: "Working with soft Rembrandt pastels, I lay in dark burnt umber in the shadows, the hair, and a little in the background. I put in the lightest lights and darkest darks and establish the middle values, such as the warm and cool reds and browns in the grandmother's face and the gold ochre in the baby's face."

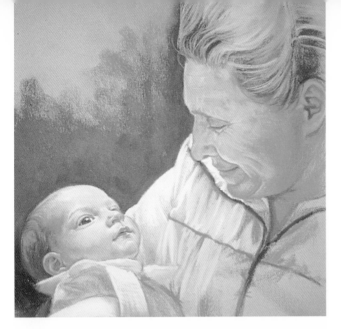

Step 3: "As I continue to layer, I work from dark to middle lights to strengthen and refine the portrait. I place a strong dark contrast behind the subject's head, with a hard edge along the grandmother's forehead, down her left arm, and around the baby's head. This dark hard edge will lead the viewer's eye to the center of interest—the baby's face."

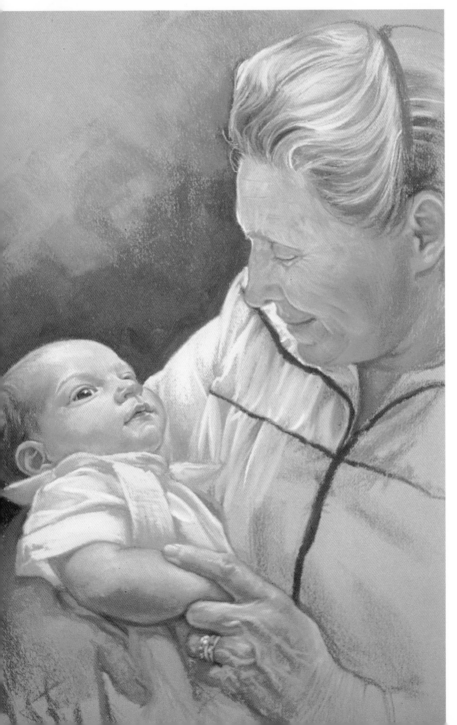

Step 4: "I soften edges in the background and add details and lights throughout as I bring the portrait to completion. I allow the tawny beige color of the pastel paper to act as the middle value and atmosphere for this portrait."

MRS. TAYLOR
AND GRANDSON
Gregory Biolchini
Pastel on Canson paper,
24" x 18" (61 x 45.7 cm).
Collection of Mr. and Mrs.
Edgar Taylor.

Using an Unlimited Palette

Marilyn Simpson, using an open, unlimited palette containing Roche, Rembrandt, Sennelier, and Schmincke pastels, paints a portrait on sand-colored Canson paper. Her technique was learned from studying with Robert Brackman. Portions of the portrait are richly modeled, while other parts are a free drawing, with the paper establishing the overall tone. "I keep it loose," Simpson explains, "placing the individual colors in with little strokes next to one another. I do not rub with my fingers nor use a fixative. I keep building color into color with broken strokes and adjusting values to the final stage."

Step 1: "I draw semi-abstractly in charcoal," says Simpson, "concentrating on the pose and the tilt of the head in relation to the body."

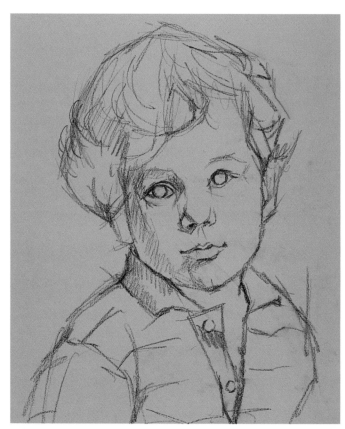

Step 2: "Brushing off the charcoal, I draw lightly and freely with a charcoal pencil, placing the features, giving special attention to the middle line of the mouth and to the ear."

Step 3: "Since the lowest values are the foundation of everything, I place the darks first, making sure they are darker than the paper. This stage is important when you use paper as a value."

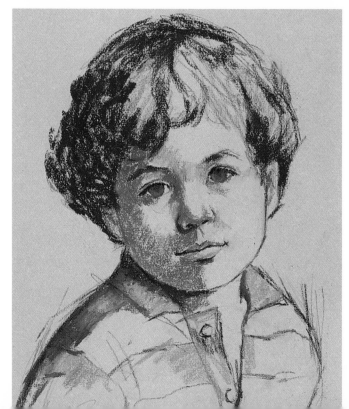

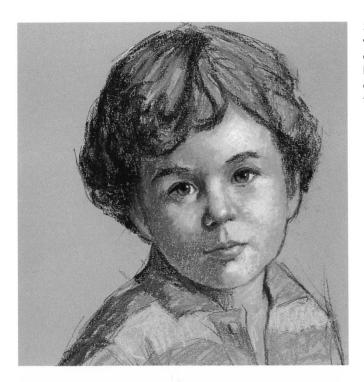

Step 4: "I lay in my middle tones without blending them into the darks. I then carefully add my lights, using rich warm to cool colors. The lightest lights are lighter than the paper."

Step 5: "Continuing to add color and adjacent values, I reconstruct when necessary to strengthen my drawing. Since the beauty of the painting still depends on tones and colors, I am careful at this final stage. I adjust my lightest lights to the end."

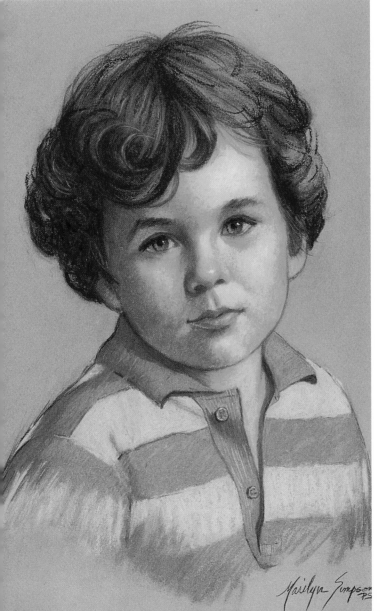

JOHNNY
Marilyn Simpson
Pastel on Canson paper,
25" x 19" (63.5 x 48.3 cm).
Private collection.

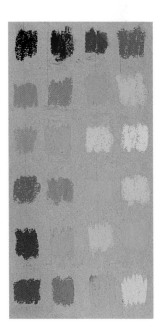

Color and value chart
for *Johnny*

Four

COMPOSING AND DESIGNING PORTRAITS

The pastel portrait that is composed well, lighted effectively, and executed skillfully displays beautiful gradations of color, a complimentary surface, good values, and graceful placement on the working surface. Additionally, the portrait captures the expression, form, and likeness of the sitter, the planes of the face and body, the shape and volume of the hair, and often maintains some of the initial linearity of the drawing. True value contrasts, reflections, and highlights add to the rhythm of the portrait, so that a highly expressive pastel will result. A glowing image emerges when good painting techniques are evident and the model's likeness is accurately painted.

SCOTTISH VETERAN
Anita Wolff
Pastel on Canson paper,
12" x 5½" (30.5 x 14 cm).
Private collection.

Format and Pose

When planning a portrait, the artist must make a series of decisions about how best to depict the subject. Will the portrait be of a single figure or multiple figures? How much of the subject is to be included—in other words, is the portrait a head, a bust (head and shoulders), a half figure, three-quarter figure, or full-length figure? Next, what sort of pose should the subject take? Should the portrait show the subject from the front, in profile, or at a three-quarter angle? Will the subject be shown seated, standing, or in an action pose? What will be in the background, and what personal objects will be included?

The choice of pose is usually explored with the potential subject, especially if the portrait is commissioned. Photographs of the artist's previous work can be helpful in making this decision.

Notebooks showing completed portraits by the artist enable the client to assess the type of work that the artist does and stimulates discussion of the type of portrait the client wants—tight and very realistic, loose and impressionistic, or some variation of the two.

After the initial decisions for a portrait are made, such as the size, the pose, how much of the figure is to be included, the type of surface to be used, and the texture desired, the clothing has to be chosen. Then the background is carefully planned, props or personal objects added, and any preliminary photography done. The lighting has to be carefully located, as the resultant light and shadow patterns often determine the success of the portrait. For more on lighting, see page 54.

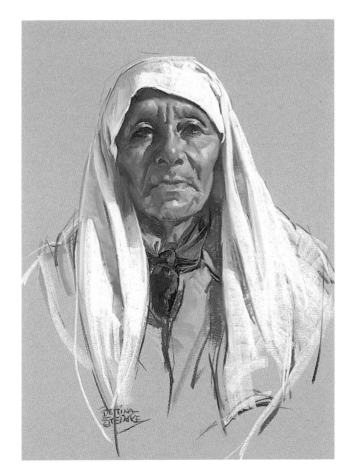

TAOS PATRIARCH
Bettina Steinke
Pastel on Ingres paper, 24" x 19" (61 x 48.3 cm). Private collection.

The patriarch, or elderly member of a tribe, is given great respect for the length of time he has lived, the quality of his life, and his relevance to the many lives he has touched. Steinke could easily have concentrated on the wise, intelligent face, the look of forbearance, or the direct inquiring gaze. She chooses, however, to highlight the white, multifolded burnoose that acts as a tactile frame for the ancient face, much like the frame of a picture for a work of art.

For this purpose the vignette, which eliminates the background as well as the foreground, is an especially effective format. Not only does Steinke capture the angularity of the bone structure, the fold and wrinkle of the skin, the luminous coloration, and the gentle and peaceful eyes, but in this instance she transcends the corporeal presence and allows the viewer to look into the soul of a man who is at peace with himself.

MONROE
Claire Miller Hopkins
Pastel on Ersta sanded paper,
14" x 12" (35.6 x 30.5 cm).
Collection of the artist.

Hopkins's loose, impressionistic
handling of the colorful profile
of a black man is frontally lit,
with the rest of the figure in
warm shadow. The clothing and
background are treated simply.

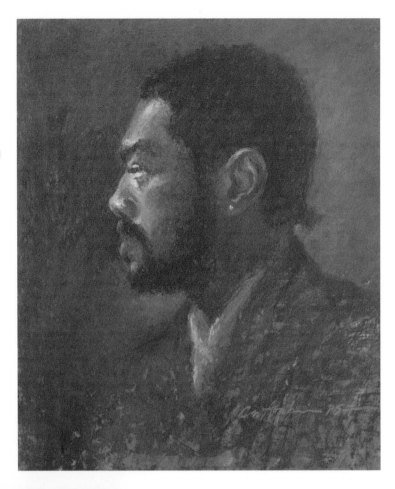

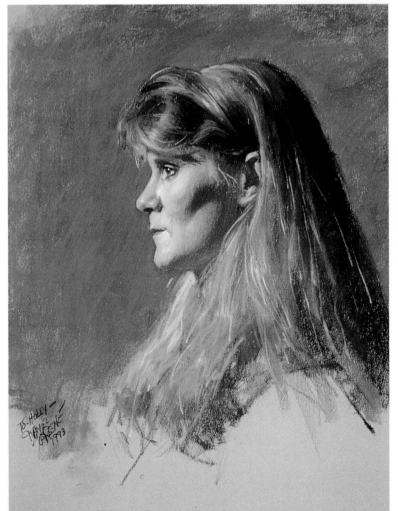

HOLLY
Daniel E. Greene
Pastel on paper,
25" x 19" (63.5 x 48.3 cm).
Collection of Mr. and Mrs. Herbert Metzger.

The profile-view portrait head of Holly, a
young woman, is radiantly bathed in warm
light that illuminates the front of her face.
Greene develops somewhat neutral flesh tones
with gentle touches of reds in the nose,
cheeks, and ears. Olive green and blue
compose the shadows to strongly delineate
the facial structure. The tones of the face are
echoed in the long hair, which ranges from
the lightest of golds to siennas and umbers.

 Holly has a lovely, lustrous quality to the
face. The variegated background in shades of
brown intensifies and integrates the model's
brown eyes. The dark browns in her hair move
softly into the background. The excellent
placement on the paper and the light and
shadow patterns are a further enhancement.

Lighting

When an artist paints a portrait, he or she is really painting the light patterns as they fall on the model. Good lighting, along with good positioning of the model, will strengthen the composition, enhance values, present the model in the most flattering way, and promote a strong composition with dramatic lights and shadows.

Directional lighting from a single source produces simple shadow forms, giving the portrait a three-dimensional appearance. The lighting may come from the side or the front, or it may be placed above and slightly behind the sitter to create rim lighting, which lights the top planes of the face and rims the head with a halo effect. The light may be soft or dramatic to capture the beautiful values of lights and darks that help promote a fresh, integrated, and coherent portrait.

The overall mood of a portrait can be established by the use of lighting. Cool lighting produces blue flesh tones and warm shadows, which can project a serious or calm feeling. Warm lighting produces yellow hot flesh tones and cool shadows, often interpreted as positive feelings.

The location where the pastel portrait is painted is an important concern. Outside lighting is far more diffuse and reflective than the carefully cast light of studio illumination emanating from a strategically placed, color-corrected lamp. Of course, the perfect light is available when you have a north-facing skylight or large window.

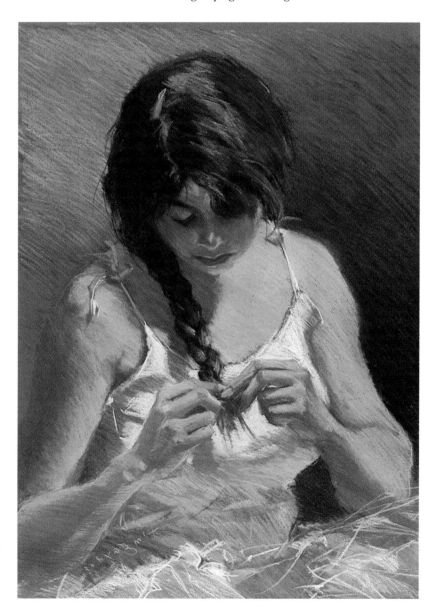

BRAIDING
Tim Gaydos
Pastel on Canson paper,
24" x 18" (61 x 45.7 cm).
Collection of the artist.

The light patterns cast from the upper left bathe the body in light and create interesting shadow patterns as the subject looks down at her braided hair. The clothing shadows repeat the background blues and grays.

Composition

The artist must be sensitive to the space breakup in a portrait, the elements to be united, and the coloring of the sitter's skin, hair, and clothing. Good composition happens when all the important elements are treated harmoniously and the portrait has a unified and integrated look. To be avoided are awkward poses, poor space breakup that puts the model in the middle of the painting, and, generally speaking, cutting the figure off clumsily at the elbow, waist, or wrist.

Whether or not to include hands is an important decision for the portrait artist, and often has to do with the size and length of the proposed portrait. Some portraits include just the head, and others include the head and part of the torso, head

to the waist with hands, and even the full-length figure. Because hands can be difficult to paint, the artist has to make sure that they are done in such a manner that they do not take attention away from the face, which is usually the focal point.

Portrait painting always includes the possibility of multiple figures, and then the decisions as to size, placement, pose, and lighting become more complicated. In a posed group portrait, all the faces must be importantly lit.

The portraits that follow show the sensitivity to the use of space that an artist develops over time. The single- and multiple-figure portraits illustrate the varied ways that figures can be arranged to compliment the subjects.

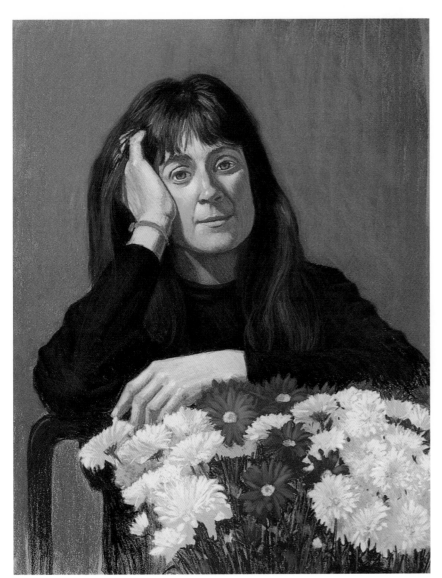

TATIANA PROMESSI
James Promessi
Pastel on paper,
28" x 23" (71.1 x 58.4 cm).
Collection of the artist.

Cool light plays over the features and hands in this dramatic picture. Tatiana, a young woman with long dark hair, dressed in black, straddles a black chair to look over its back. It is a pensive and luminous portrait. A triangular composition, it has all the pictorial elements poised to direct the viewer's attention to the face. The dull yellow-gray background repeats some of the skin colors, and the red and yellow flowers repeat the reds in the subject's complexion and hair. This is an excellent example of a portrait in which the luminescence derives from the finely knit colors and a thorough understanding of lights and shadows.

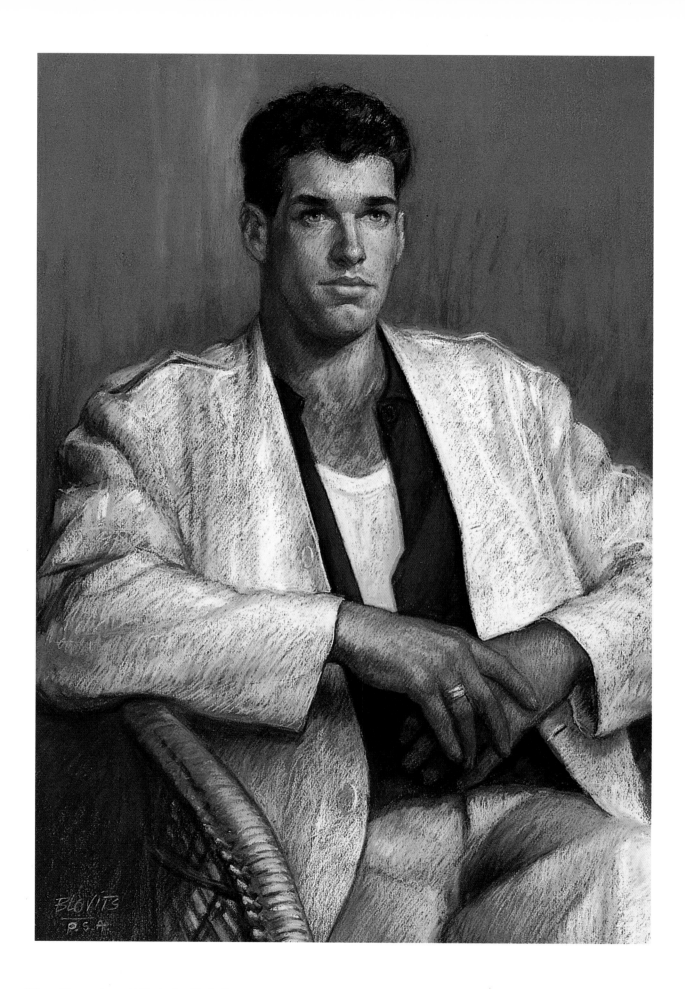

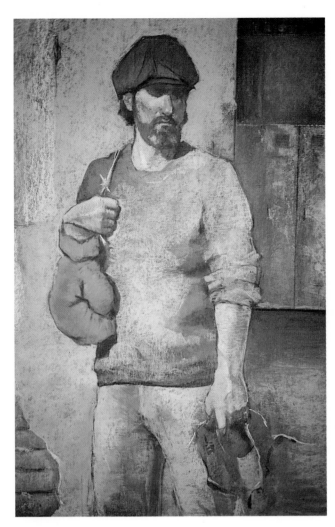

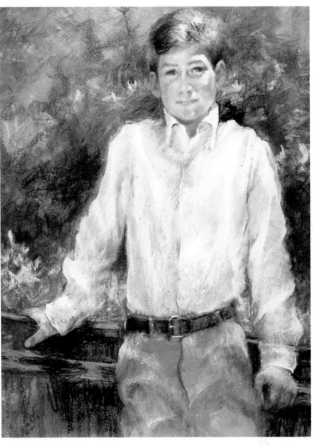

ALDO
Alexander Piccirillo
Pastel on sanded wood panel, 38" x 32" (96.5 x 81.3 cm).
Collection of the artist.

In this three-quarter figure, the light is cast from the upper left, causing dramatic shadows. It reveals the artist's fascination with boxing, rough working surfaces, and the careful delineation of hands.

ALEX VIDALA
Dorothy Barta
Pastel on paper, 30" x 22" (76.2 x 55.9 cm). Private collection.

The careful placement of a young boy is complimented by its graceful position on the paper. Note carefully the uneven space divisions on each side and the luminous color and lighting patterns.

MITCH
Larry Blovits
Pastel on Canson paper,
25" x 19" (63.5 x 48.3 cm).
Collection of the artist.

Larry Blovits has placed the head almost in the center, looking forward, while the shoulders and body are tipped sideways, creating a relaxed three-quarter portrait. The blue of the background is echoed in the shadows of the white suit, causing a vibrant color contrast against the skin tones. Well-defined hands in subdued values enhance, rather than detract from, the luminous face.

CAREY PORTRAIT
Jill Bush
Pastel on pastel canvas,
30" x 40" (76.2 x 101.6 cm).
Private collection.

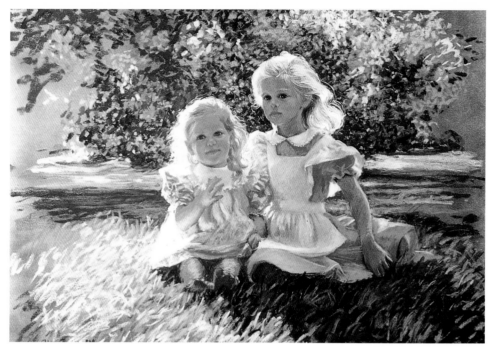

Jill Bush has placed the two Carey girls to the right of center for good space division. She uses rim lighting and impressionistic pastel strokes to capture a moment in time. Colors are artistically used and reused throughout the composition.

SIESTA
Gregory Biolchini
Pastel on sanded pastel paper,
22" x 32" (55.9 x 81.3 cm).
Collection of Mr. Gerald Norrad.

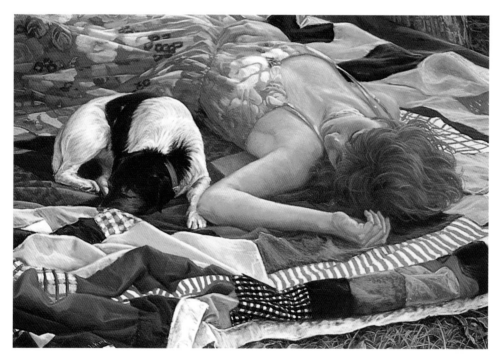

A diagonal position is chosen for the sleeping female, and the semicircular shape of the dog adds excitement to the sleeping figures. They divide the working surface into interesting shapes and subdivisions. With varied negative shapes, the complementary colors add visual velocity to an otherwise static image.

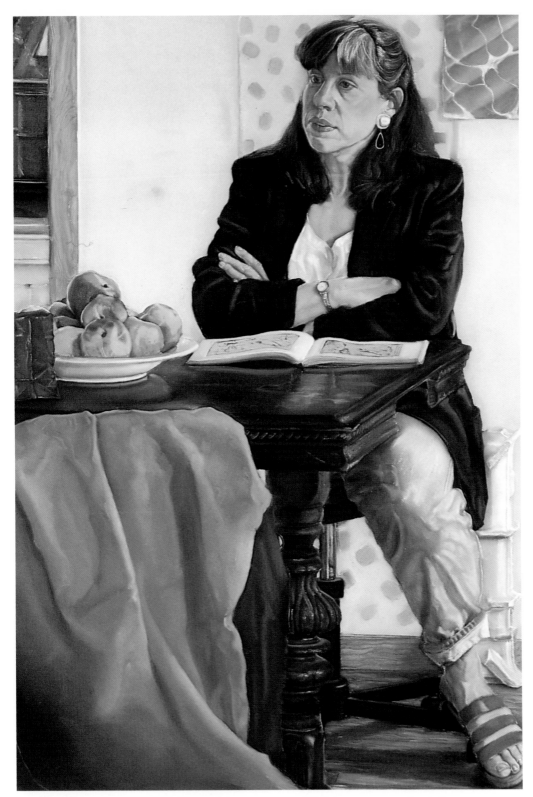

MARTHA
Jonathan Bumas
Pastel on paper
prepared with acrylic
and quartz crystals,
44" x 30"
(111.8 x 76.2 cm).
Collection of the artist.

Because the subject is a historian whose interest is 17th-century Dutch baroque painting, Jonathan Bumas creates a composition in the genre of Vermeer. He places the figure in an interior, sitting at a table, which helps to anchor her. Bumas seeks to avoid isolation of the subject, and composes a portrait that seems to be lifted from a larger social context. Here the subject is caught in the expressive act of conversation with a person who is not seen. Repeating colors tie disparate elements together, and the integration of lights and darks gives the composition harmony.

Composing a Full-Length Portrait

Bob Graham paints a radiant pastel portrait of a beautifully dressed young woman sitting in a garden. "My greatest challenge," he says, "is to re-create the special qualities I see in light. Painting the figure outdoors is one of my favorite challenges. Since late afternoon light is subtle, I use great care in choosing bright, clear pastels to model the features. I am working from photos only, so I have to rely on my previous experience painting afternoon light. I am further challenged when, late in the evolution of my portrait, I adjust the angle of the head.

The direction of the afternoon lighting influences the pose, and the dark negative shapes dictate the placement. Graham notes, "Part of the challenge of the painting is working without being able to return to the scene."

Step 1: "I draw a charcoal sketch on pumice board that has been sprayed with a coating of fine pumice and Golden acrylic matte medium," says Graham. "The surface is very smooth. To capture natural body language, I concentrate on the model's likeness up close, then I introduce the light and shadow patterns of the skin."

Step 2: "Loose strokes indicate the light and shade of the other elements. In a very colorful way, I add to the light plane of the skin. This greatly enhances the quality of the light."

Step 3: "I paint the background with brown and red at the right bottom, and brown and turquoise to the left of the figure. I use a 1-inch white bristle brush with a dilute mixture of fixative and ground pastel sticks."

Step 4: "At this point I make a difficult decision, to adjust the angle of the head. After brushing off as much pastel as possible, I rough in a new head pose and develop it in the same way as the original head. Olive green is added to the shadow plane of the face, and variations of the light plane are scumbled in loosely."

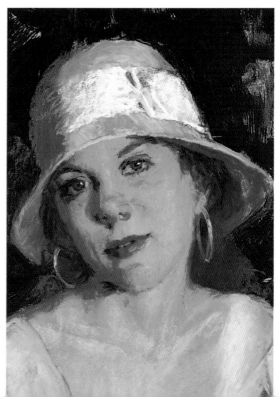

Step 5: "Concentrating only on the face and neck, I use a dark red-violet to improve the shadows. The light plane is worked with yellow, rose orange, light yellow-green, burnt sienna, and blue-violet. The design of the dress is worked with the halftone. I add fine finishing touches to bring the newly painted head to the level of the rest of the nearly completed figure."

Step 6: "The design of the dress is completed, with plenty of attention given to the folds of cloth. I make last-minute changes in the values and stop myself before I overwork the painting."

KATHERINE VESEY
Bob Graham
Pastel on pumice board,
60" x 40" (152.4 x 101.6 cm).
Collection of the artist.

Composing with a Grid

Using photography as the basis of her composition, Dorothy Barta places the figure on a grid, uses a proportion wheel, and constructs the figure on Ersta sanded paper. Working out the contours, she joins the form shadows and cast shadows to make the patterns of dark and light. She explores many experimental ways of painting a multimedia pastel, and creates a luminous portrait of her daughter Sharon, the prima ballerina of the now-defunct Dallas Ballet.

Step 1: "I place tracing paper on top of an original photograph and copy it," Barta explains. "This provides a guide for drawing and composing without the distraction of color."

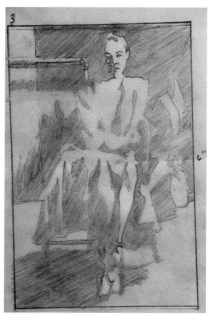

Step 2: "Shadows are contoured when I find the edges of the cast shadows and form shadows and join them together to make light and dark shapes."

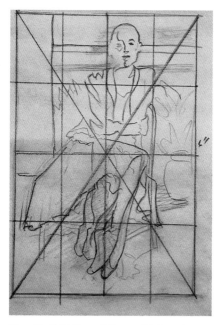

Step 3: Gridding: "After gridding the original drawing and making the necessary changes, such as repositioning the leg, I use a proportion wheel and ruler to enlarge the grid to the size I plan to use for the painting."

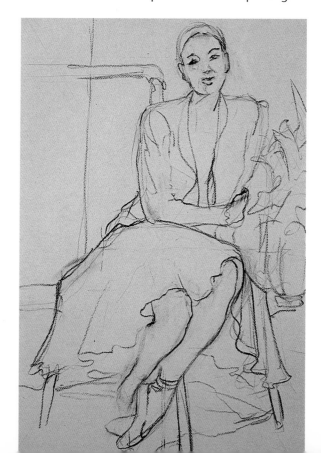

Step 4: "I do a freehand gesture drawing the size of the painting to acquaint myself with the placement."

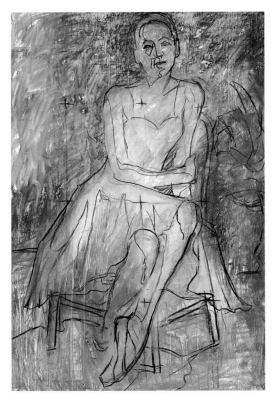

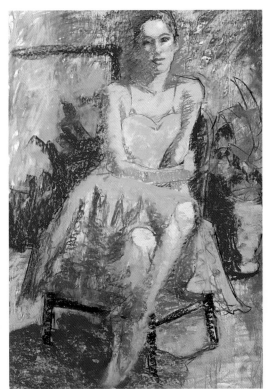

Step 6: "After loosely laying in flat color and establishing the darks, with little thought of details, I concentrate on the shapes of the local and complementary colors."

Step 5: "Working in pastel with complementary colors, I lay in color patches and wash the surface with a synthetic brush and turpenoid. I make a freehand gesture drawing on the color-washed sanded paper, using the prepared grid for placement. Earlier, marks to indicate the intersecting lines of the full-size figure were placed on the grid to prepare for this drawing step."

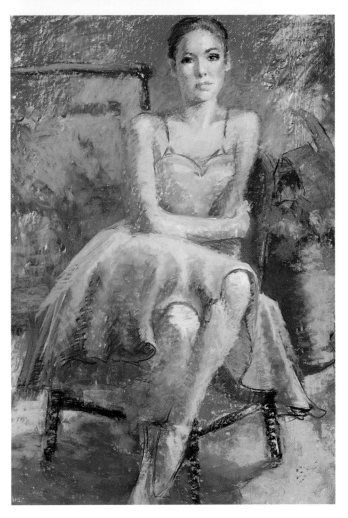

Step 7: "I refine and finalize the painting. I could carry it further to a fine finish, but I like to have a little mystery in my paintings."

SHARON KAY SEEMANN
Dorothy Barta
Pastel on sanded paper,
28" x 22" (71.1 x 55.9 cm).
Collection of the artist.

Using Color and Props to Capture Personality

Dorothy Barta paints an evocative portrait that conveys a sense of the subject through bold jewel-tone color, textural hatching and crosshatching, superb control of edges, and a surface luminosity that develops with the successful coalescence of color and value. The subject, Charu Shah, is an abstract artist, and Barta wants to incorporate her abstract art and Indian artifacts. Her intent is to create a beautiful, revelatory portrait of a colorful subject. The composition is based on the tried and true compositional tool of the Old Masters—the unequal triangle.

Step 1: "I begin with a simple charcoal contour drawing," says Barta. "Of paramount importance is the location of the figure on the sanded paper surface. Using bright jewel tones, I lay in flat local color over the entire picture surface."

Step 2: "I reestablish the drawing again with soft charcoal."

Step 3: "With the second layer of pastel, I cover the whole surface and establish the primacy of dark, compelling values. I add light and middle values to the subject and make similar color and value judgments about the clothing and pillows."

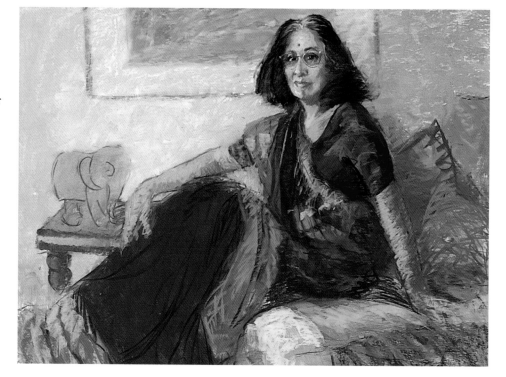

Step 4: "This detail shows the addition of light and the pointillistic hatching and crosshatching strokes used to develop strong values."

Step 5: "Loose scumbling of light values over dark develops layers of complementary color. Note the soft edges of the sides of the face and hair as they are feathered into the background. Found edges are where the light hits directly on the chin, nosepiece of the glasses, and parts of the bridge of the nose."

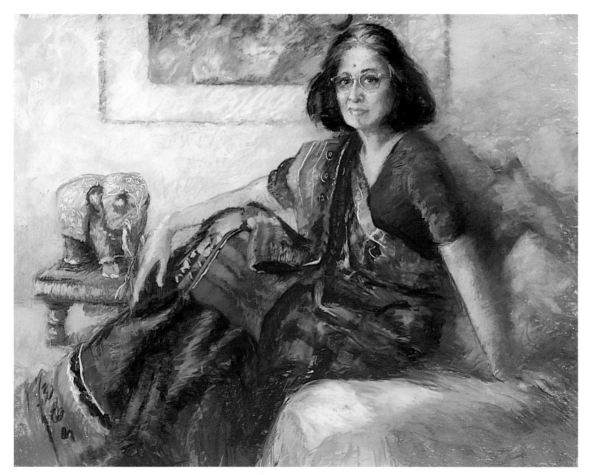

CHARU SHAH
Dorothy Barta
Pastel on sanded paper,
22" x 28" (55.9 x 71.1 cm).
Collection of the artist.

Step 6: "The finished portrait shows all the pictorial elements easily integrated into the picture. The artwork is pushed back with a reduction in color, softening of edges, and lightening of the background's hue. All parts are checked for value, stroke, and edge. Final value and highlight adjustments are the finishing touches."

Working from Photographs

As long as artists paint, there will be differences in how they incorporate photography into their work. Most portrait artists use photographs adjunctively, to serve as reminders of shape, color, shadows, and so on or to record outdoor backgrounds or room interiors. Photography can be used to experiment with lighting, clothing, and finding the optimal angle or position. Photographs also free both the sitter and the artist from hours of tedium. By working from snapshots of clothing and accessories, the artist can progress on a portrait when the model is unavailable.

In commissioned portrait work, photographs can help in the selection of pose, lighting, location, clothing, and accessories. The subject is able to see the most attractive body and face positions, the effects of different types of lighting, and the suitability of the choice of clothing and props. Photographs enable the artist to paint the clothing and develop the background alone in the studio. The portrait may be finished in the desired time, even if the subject is unable to be present for the desirable number of sittings.

Portrait painters use photography far more than they may admit. They can complete large segments of a painting before the model is present. Black-and-white photographs are helpful in identifying values and are often used to save time. The live model is needed, however, to create proper flesh tones. Color photography often distorts natural color, and the subject may take on a green or blue cast. Some colors exist on 35mm film that are not true to life. Exaggerated values of ultramarine blue may be helpful in painting a sky, but in a person's complexion they are bizarre.

When a pastelist works on children's portraits, it is almost a necessity to have backup photographs. It is difficult for a child to sit still for long periods of time. Additionally, the constraints on children's time are sometimes quite extreme. When children have little free time, trying to get them to pose consecutively can cause delays. Well-taken photographs allow the artist to keep working on noncrucial parts until the child is able to pose again.

In portraits of two or more people, the arrangement of the subjects can be a major problem. Good group pictures are needed, and separate photographs of each person are also helpful. This type of painting is time-consuming, and chaos may result when you try to create the same pose each time. This is a crucial instance when a few photographs can save your sanity. Photography also provides a good opportunity to manipulate the placement of the members of the group.

All portrait painters know about "capturing a moment in time." Challenging indeed are portraits of an athlete flying through the air on a skateboard, swinging the bat at home plate, or executing a back flip on a trampoline. All these are within the purview of the portrait painter who can work with small amounts of information, a large amount of resoluteness, and a good camera. Hopefully, most of the subjects will be available for an analysis of skin tone and hair and eye color.

A photograph for portrait work is only a visual description of a person or persons in an environment. It takes great skill to use slides adjunctively, to assist in the placement of the drawing, or to serve as a reminder of details, lighting, values, and form. Unfortunately, some portraitists take slides and project them onto the surface of their painting. Without the skills carefully honed from years of study, they end up with portraits that are wooden and flesh tones that are lifeless. In the hands of a skilled artist, however, the photograph can be an indispensable tool.

Using Photos in a Children's Portrait

Jill Bush uses photocopies and photographs as aids to painting a double children's portrait on rough pastel canvas. She takes up to 200 photographs during the preparatory phase of her work. There are photography sessions set up in the morning and late afternoon to capture one or more subjects in a natural setting. This approach is particularly useful when there are two or more children in the same picture. Of course, sittings with the models are also required for working on certain features and for correcting areas of the painting as the work progresses.

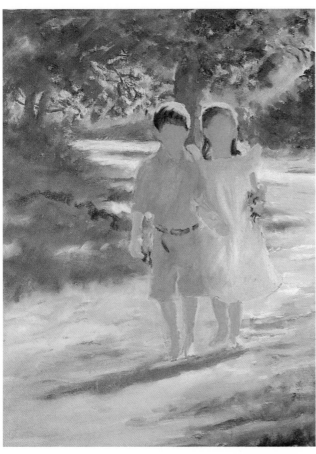

Step 1: "After laying in a broad base with pastel," Bush explains, "I scrub water into the pastel with a bristle brush to create a wash."

Step 2: "I establish the lights and darks with pastel, then indicate the features, using the darkest umber for the girl's eyes. The developing portrait is on the easel with photographic aids. The photograph is on the left, and the photocopy on the right. I scan the painting constantly for shapes that need correction."

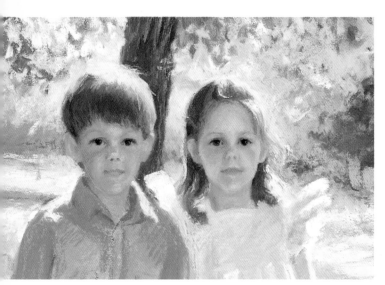

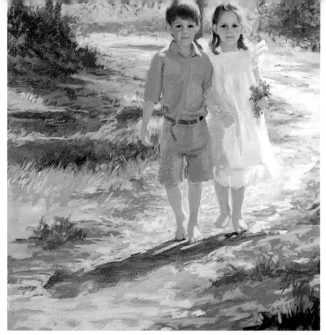

Step 3: "In a two-hour sitting for each of the children, I obtain much detailed information to move the portrait forward. I bring the landscape to the same finish. Intensifying the lights and darks with large Sennelier pastels, I vary the touch and angle of the strokes."

Step 4: "Now I work to establish the children's legs and the path, thinking of positive and negative spaces. Violets are used for the road. I grind pastels using a mortar and pestle (I have four), mixing them with water and rolling them into new colors. I paint and layer color to produce richness on the rough surface. The white dress is developed with red and blue-violets, greenish blue-gray and burnt umbers. The boy's clothes are modified with umbers, greens, and violets."

Step 5: "As I progress on the background, I work all over the painting as inspiration leads me. These children are delightful and I feel my own spirit lighten as I attempt to capture theirs. Transferring the almost-completed painting to my large studio, I am able to back up and really scan the portrait to do final corrections, balance all the shapes, and achieve unity."

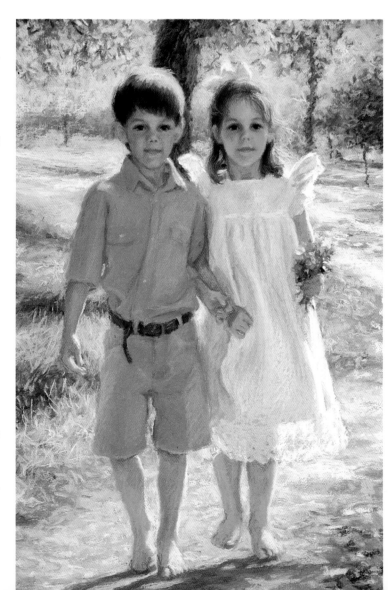

CAROLINE AND CAMPBELL WAGNER PORTRAIT (DETAIL)
Jill Bush
Pastel on Fredrix pastel canvas, 40" x 30" (101.6 x 76.2 cm).
Collection of the Wagner family.

Painting from Projected Slides and Polaroids

Greg Biolchini uses a rearview projection screen for enlarging slides and Polaroids. He finds the slides helpful for painting details and reviewing and working on other parts of a painting when the model is not present. While the model is present, he does a full-color study from life to capture the accurate coloration of the flesh areas, hair, lips, and eyes. That way he does not have to make them up when he is at work with the slides. "The colors in a photograph will never come close to matching the colors seen in real life," the artist says. "I also think that doing a color study helps familiarize one with the subject, making it easier to interpret the likeness from flat photography." The technique he uses for the color study is the gradual buildup of overlapping layers of pastel. He starts with dark pastels in the shadows and gradually lays in middle values and lights.

Step 1: "On carefully prepared pumice board, working from photographs and slides," says Biolchini, "I draw a rough charcoal drawing with large, bold strokes to delineate the lights. Avoiding detail at this stage, I work with a kneaded eraser and charcoal. Dusting away most of the charcoal, I leave a light ghost drawing."

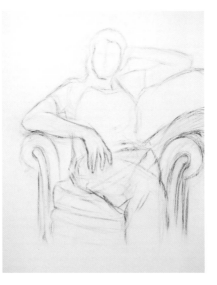

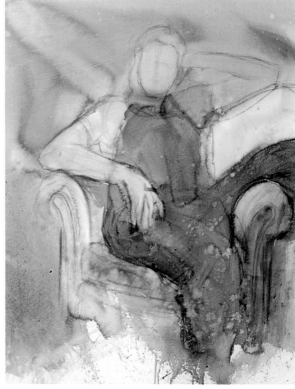

Step 2: "To act as an overall tone, with a large paintbrush I paint a loose wash of burnt umber over the board. I paint flat, then prop the board up vertically to make the wash run. This is allowed to dry. I keep the chair and backdrop set up in my studio. With borrowed bib overalls from my model, Breanne, I match the colors of a wash to all these props and paint it loosely into and over my drawing."

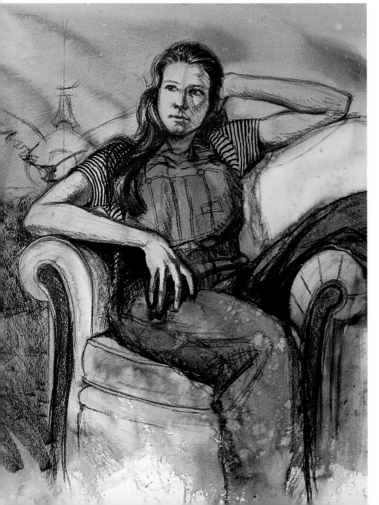

Step 3: "Over the washed background I scumble with burnt umber pastel. I use charcoal again to restate the pattern of the tapestry background and more clearly define the shapes for the hard, dark pastels."

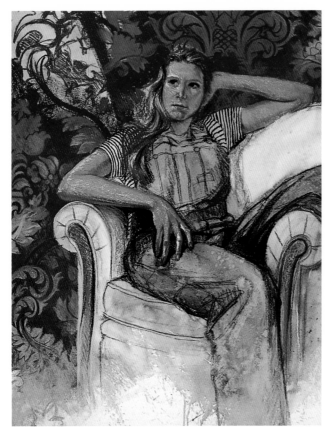

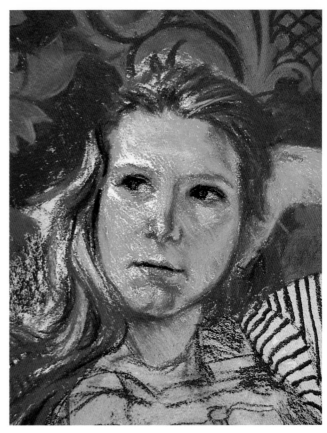

Step 4: "The intrinsically interesting antique tapestry is chosen as a sharp contrast to the young model. Working from dark to light, all background values are blocked in. My application technique is to lay in all shadows and halftones a little darker and richer in color as a pastel underpainting. Polaroid closeups of the face and hands are used, along with my preliminary study."

Step 5: "Referring to a slide in the rearview projection system, Polaroid closeups, and the preliminary study, I work in a low-key palette. The detail shows the extreme darks and intense colors of the blocking-in process."

"This projection booth is used for the portrait of Breanne. Made with a piece of ⅛-inch-thick Plexiglas, finely sandblasted on one side, it is mounted over a 28-inch-square hole cut in a hollow closet door. I put a carousel projector in the back of the booth at eye level to project the enlarged 26-inch image on the Plexiglas. I find that this is very helpful in some portraiture."

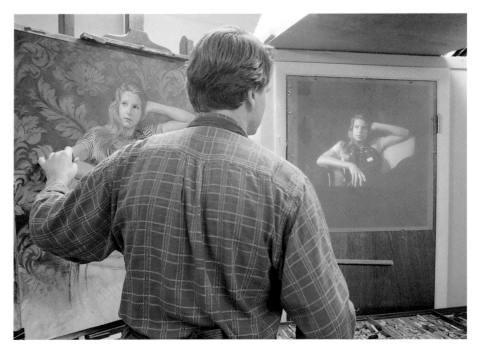

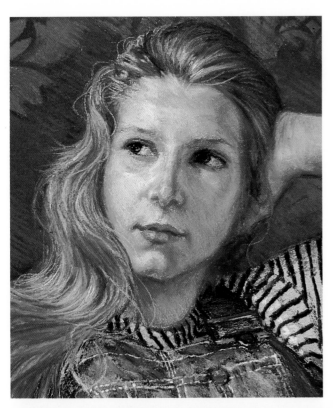

Step 6: "This is a detail from the finished portrait. I blend lighter tints over the intense colors and darks. To add finishing touches, I refine the likeness, adding layers of pastel and working from dark to medium to light."

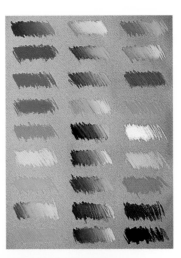

Color chart for *Breanne:* "From dark to light I use 27 colors from four different manufacturers: NuPastel, Rembrandt, Yarka, and Holbein. There are six reds, three oranges, one yellow, three greens, two blues, seven browns, four grays, and black."

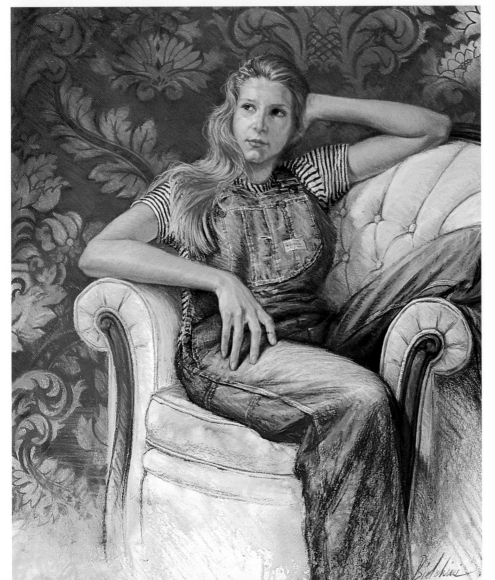

Step 7: "To complete the portrait, I use an unlimited full-color palette. My intent is to say something of her youth and independence through her posture, expression, and clothing as well as lighting and environment."

BREANNE
Gregory Biolchini
Pastel on pumice board,
40" x 30" (101.6 x 76.2 cm).
Collection of Mr. and Mrs.
Donald Thomson.

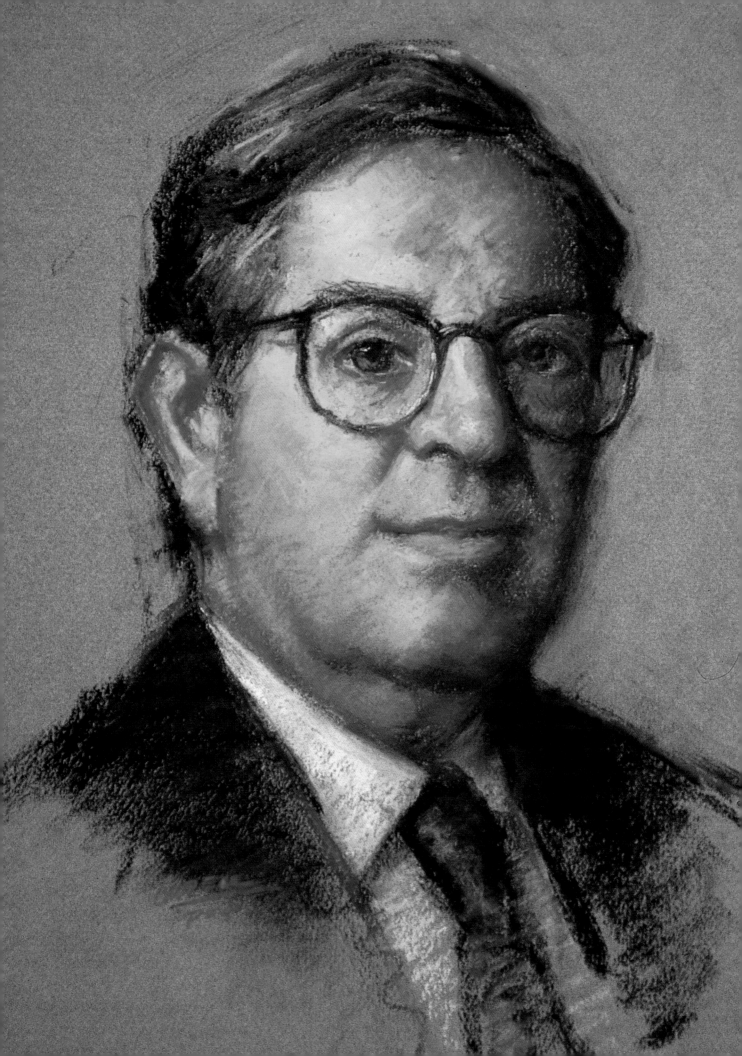

FACIAL FEATURES AND HANDS

The development of the eyes, nose, mouth, and ears is critical to the portrait artist because the likeness of the subject depends on whether they are drawn correctly. Working on the individual features of the face usually begins when the artist starts to refine the preliminary drawing. Many artists insist on a very accurate drawing before applying color; others start loosely and correct and refine as they work.

Because the portrait may be a front view, three-quarter view, or profile, the portrait artist must be able to draw facial features from different angles. It is not enough just to render each feature accurately; the eyes, nose, mouth, and ears must also be placed correctly and in proportion to one another. In this chapter, different artists will demonstrate the sequential development of eyes and mouths; the complete modeling of the face, feature by feature; and the rendering of a child's features. Other demonstrations will show the definition and completion of hands and the progression of color and values in painting hair.

PORTRAIT OF DR. CARL CONRAD
Foster Caddell
Pastel on paper,
24" x 20" (60 x 50.8 cm).
Collection of the artist.

The Eye

If one feature may be said to determine the likeness of a subject, it would have to be the eyes. As in the saying "The eyes are the mirror of the soul," so too they are the mirror of the personality. In frontal portraits especially, the eyes often give the impression of looking at the viewer, making them the dominant or most important feature. After the preliminary sketch, many artists begin working on the eyes first. Getting them "right" makes adding the other features easier.

In the following demonstration, Rhoda Yanow, a New Jersey artist, develops the eye using basic materials—toned paper with a retentive surface and simple pastels.

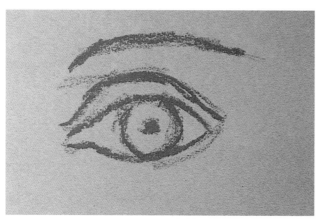

Step 1: Yanow begins by drawing lightly with a NuPastel #313P to indicate the general contours of the eye.

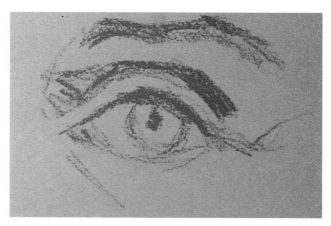

Step 2: She continues expanding and refining the drawing and defines the areas of light and shadow with the same shade of pastel.

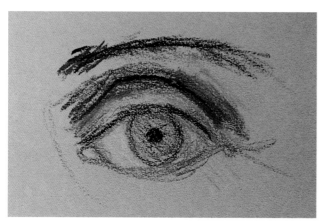

Step 3: Next, Yanow corrects the drawing and begins to add color to better establish the lights and shadows. For this subject she chooses black, olive green, flesh color, Van Dyck brown, and light red.

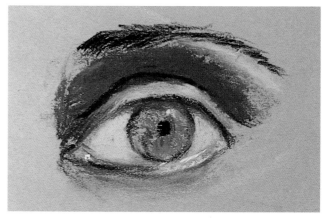

Step 4: To amplify and develop a lively, sparkling eye, the artist strengthens the colors. Note the use of multiple colors in the iris, the dark value of the so-called white of the eye, and the addition of reds for realism. The lid casts a shadow onto the iris, and the sparkle of the eye is cast with a few dots of off-white. The areas above and below the lids of the eye are darkened. The eyebrow is developed with the addition of small individual marks.

The Mouth

An expressive feature, the mouth plays a leading role in setting the mood of the portrait. Just think of the importance it has in Leonardo's *Mona Lisa*. The mouth may be smiling, pensive, pouting, half-smiling, down-turned, or even hidden by a mustache. Whether or not the subject is shown smiling should be determined by the person's character. Does he or she smile and laugh easily or have a more serious nature? Another factor to consider is the formality of the portrait; traditionally, more formal portraits do not show the subject smiling.

James Promessi, a California artist, demonstrates how he develops the mouth from charcoal to pastel, using as his models a middle-aged man, a six-year-old girl, and a young woman.

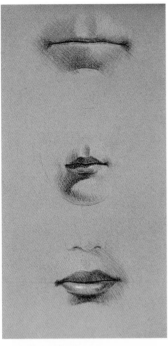

Step 1: The value drawing, done on toned paper and heightened with white, uses a raking side light. Variously shaped philtrums (depressions above the lips) and mouth corners are handled carefully.

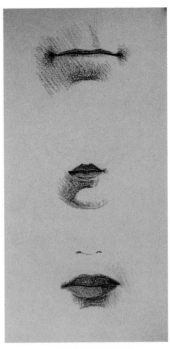

Step 2: The artist now concentrates more fully on color. "The first step," says Promessi, "is to lay in the darkest darks, in the line between the lips and the corners of the mouth, in umber and burnt sienna. I will lay in the lighter shadow also with the same colors in lighter shades."

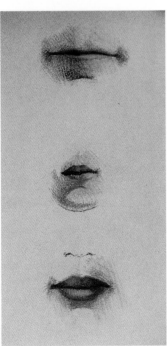

Step 3: He adds more color in lighter shades, including shades of caput mortuum, red, scarlet, Mars violet, light red oxide, gold ochre, and mouse gray. The red hues are used to redden the lips, increasing their color intensity. The lighter values help model the red lip forms and are also applied with open strokes to the flesh areas surrounding the lips.

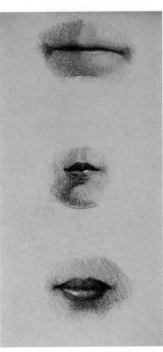

Step 4: The final development and heightening of the mouth colors is accomplished. Highlights are placed, and the flesh surrounding the mouth is brought to an equal finish.

Shape, Proportion, and Color

Emphasizing shape and proportion, Marilyn Simpson, with remarkable precision, shows that drawing is key to capturing a good likeness. Here she carefully renders a subject's eye, nose, and mouth on gray-toned paper in a charcoal value drawing heightened with white. She then develops the color scheme using a wide range of luminous hues.

Establishing Shape and Proportion

Simpson begins by concentrating on the size, form, and values of each facial feature, working in charcoal to eliminate the distraction of color for the moment.

Nose: Because the proportions of the nose have such an important influence on the character of the face, the artist needs to study and draw noses of various shapes and sizes. Delicate shading and lighting are used to emphasize the individual planes of the nose.

Eyes: Note that the eyes of every person are never a perfect match. There is a difference in their size, in the shape of the lids, and in the skin folds. The upper lashes are heavier, fuller, and darker than the lower. The eyebrows are also not identical. When viewed from the front, the distance between the eyes is roughly the width of one eye. The upper lids cast shadows on the eyeballs, which should be painted very close to the value of the skin tone. The highlights in the eyes should not be too large

and should be placed to reflect the direction of the light in the rest of the painting.

Mouth: The corners of the mouth control facial expression, which is determined by whether the corners turn up or down. When painting the mouth, note that there are observable differences in tone between the lower and upper lips, with the lower lip lighter in tone. The character of your model lies in the shape of the darkly toned line that separates the upper and lower lips.

Developing the Colors

In the illustration shown here, the nose is developed through the use of flesh colors, such as red ochre, burnt sienna, burnt umber, English red light, moss green, and white.

The lip colors are a vivid and beautiful mixture of crimson, carmine red, alizarin crimson, flesh, and white. The lips are modeled carefully, as is the philtrum, the vertical groove between the nose and the upper lip. The top lip is darker and more in shadow, and the corners of the lips set the expression of the face.

The eye is meticulously developed, as its shape and expression are most important. The usual flesh tones are enlivened with dark siennas and black, and the eye is made iridescent with the addition of ultramarine and cobalt blue. White is judiciously added for light and sparkle.

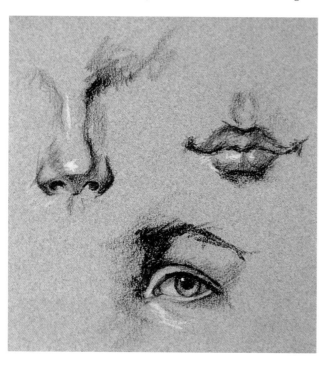

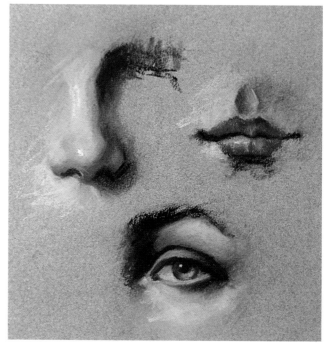

A Child's Features

Because a child is constantly growing, his or her facial features and body proportions are different at different stages of development. A toddler's features are very different from those of a seven-year-old, and the seven-year-old's contrast dramatically with those of an adolescent. It is therefore important that the portrait artist observe and understand these differences. The artist cannot apply the rules of proportion for adults to children, nor the proportions characteristic of one young age to another.

Marbo Barnard, a California artist, shows how she plans the facial features for a child's portrait. Each feature is developed individually in a four-stage sequence. Barnard then takes the idea even further in a unique and imaginative sequence showing how she incorporates each feature into the face until the child's portrait is complete. All the shades used in these last two demonstrations are shown on page 79. The range of chromas, values, and hues used is often surprising, as some of the colors are not readily seen in the finished portrait.

Eyes

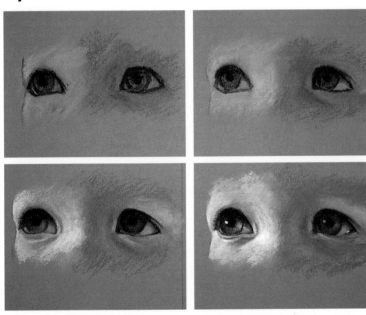

Nose

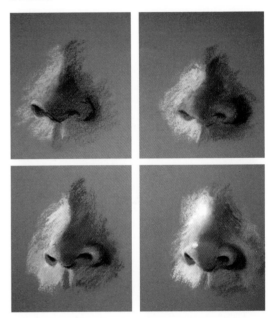

Step 1: Using Canson paper, Barnard establishes the drawing in dark brown NuPastel. Shadow and flesh tones are added to the eyes.

Step 2: Blue-gray is added to the eyeballs, and light gray to the white parts of the eyes.

Step 3: Light flesh tones are used to start the modeling around the eyes, and the underside of the eyelids starts to develop.

Step 4: All parts of the eye are reworked. Because the cornea is transparent, light coming from the left side causes reflections on the opposite side of the eyeball. The color development is advanced using shades of blue, and red is added to the corners. As a finishing touch, strong white highlights are added and graded on the shadow side.

Step 1: The nose is sketched in using dark brown NuPastel. Flesh tones are added to start the modeling of the nose.

Step 2: The tip of a child's nose is fleshy, with more roundness than an adult's, and Barnard develops it accordingly.

Step 3: A child's nose is shallow and does not show much change in plane. From the forehead to the nostrils there is a lost and found effect. Barnard uses Grumbacher red ochre to develop the light side of the nose and burnt sienna and burnt umber to darken the shadow side.

Step 4: Red is added to the nostrils, and the highlights of the nose are done with light oak.

Mouth

 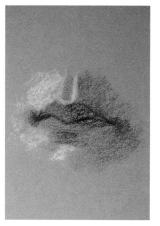 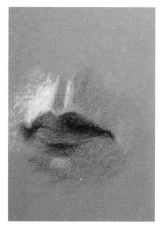 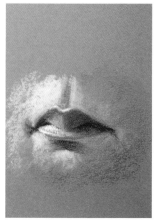

Step 1: The lips establish the size and shape of a child's mouth. The upper lip is longer and protrudes beyond the lower lip. Barnard again uses dark brown NuPastel to draw the outline, emphasizing the bulge in the upper lip that fits into the curve of the lower lip. This is typical of a child's mouth.

Step 2: The mouth gains more glowing reds and flesh colors, and the dark and light sides of the mouth are further delineated. The shape of the philtrum is defined and illuminated, and flesh and gold ochres are added to the area below and around the lips.

Step 3: To avoid a "pasted-on" look, the corners are softened and blended into the skin tones. The shadow under the lip and the corners of the mouth are established in dark brown.

Step 4: Light oak is used for the highlights in the flesh, and pink for the highlights in the lips.

Ear

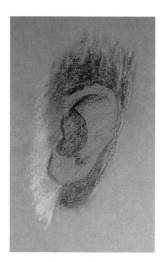 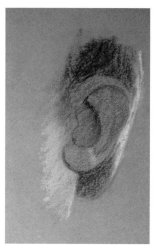 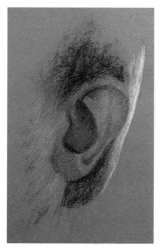 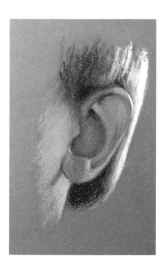

Step 1: The outline of the ear is drawn with dark brown NuPastel. The ear is in shadow, with strong light coming from the back of the head.

Step 2: Using warm colors and working from dark to light, Barnard models the ear. She adds cadmium red light to the upper ear to enhance the ear's shape and augment its natural transparency.

Step 3: The artist continues refining the bowl and outer edge of the ear. Yellow ochre is used to begin highlights on the hair.

Step 4: Strong yellow ochre light on the hair and reflecting highlights from behind cause the cadmium red light on the upper ear to appear transparent. Cast shadow is added below the ear.

Portrait

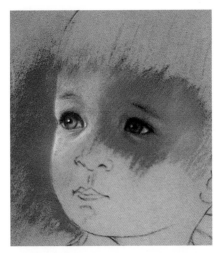

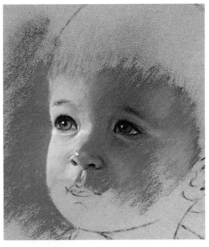

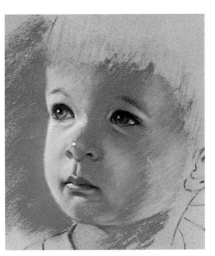

Step 1: Working on Sennelier La Carte light gray paper, Barnard establishes the drawing in dark brown NuPastel. Using light and dark flesh colors, she begins modeling the face. She then places and fully develops the eyes, as shown on page 77. The undeveloped part of the head and other facial features are shown in outline.

Step 2: Next, the artist develops the nose in full detail using warm flesh, orange, red ochres, and burnt siennas. The colors and the technique for developing a child's nose are shown on page 77. The undeveloped features and the rest of the head are still outlines.

Step 3: The child's mouth, with its protruding upper lip, is worked in soft reds and pinks. Burnt umber is used to emphasize the shape of the mouth and the corners.

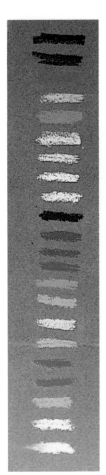

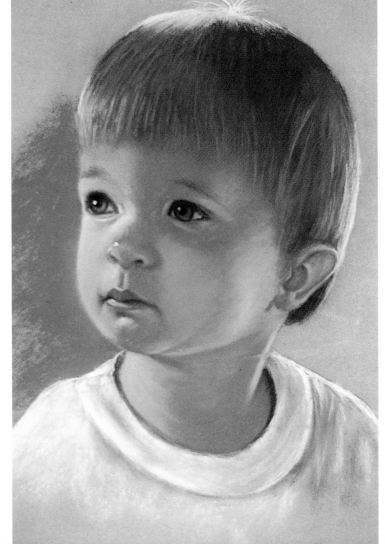

Step 4: Light grays and blues are added to the flesh colors of the face and are echoed in the clothing and background. The edge of the cheek is lost. Ochres, siennas, browns, and yellows are added to the hair to show texture.

The chart at left shows the colors used in the portrait.

Lighting and Angle

The position of the lighting has a dramatic effect on the features of the face and the mood of the portrait. It is important to study the shadows created by lighting, especially those cast by the brow ridge, nose, philtrum, lower lip, and chin. Be sure to place light sources so that the pose is flattering and there are no harsh shadows cast by or on the facial features.

In the four examples on this page, Jim Promessi shows the patterns of light and shadow on different views of the head when it is illuminated in a variety of ways.

For this frontal portrait, the light source is high and from the right, lighting the left side of the model's face. The hair is treated as a simple mass and curved form, with a highlight on the top right. The eyes, right side of the model's face, and most of the nose are in shadow. Simple lights and darks treat the beard as an uncomplicated form.

The second frontal view has light coming from the left and high. The forehead and left side of the face are in light. The nose casts a shadow on the cheek. The raking light makes the structure of the features and the planes easy to see.

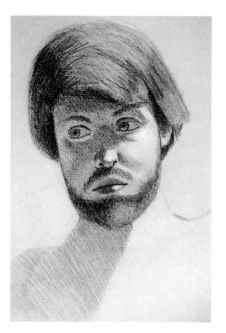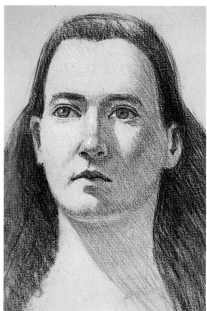

This three-quarter view is illuminated by high frontal lighting. The whole front of the face is bathed in light. There is a large turning edge that starts at the top of the cheekbone and divides the face into simple frontal and side planes.

For the simple profile on the right, the light source is high and frontal. You can see the shape of the side plane of the face and the subtle swelling of the cheekbone. The tubular curve of the lips wraps the mouth, delineating it.

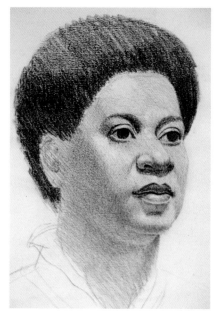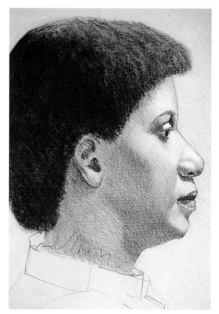

Feature Placement

When planning a portrait, Wende Caporale first assesses the proportions of the face. The length is marked at the forehead and chin, and these nonadjustable marks serve as a boundary for the scale. The face is divided into thirds: the hairline to the top of the eyebrows, the top of the eyebrows to the bottom of the nose, and the bottom of the nose to the bottom of the chin. Rarely equal, these divisions are used as a starting step. "No attempt is made at this time to draw the outline of the face," says Caporale, "for I have found a more successful approach in working from the inside out, a phrase coined by my husband, artist-teacher Daniel E. Greene."

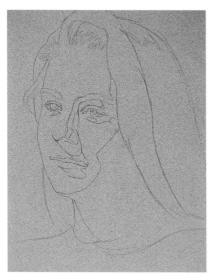

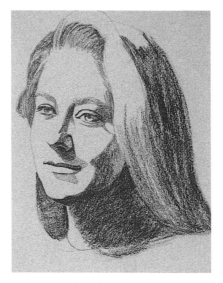

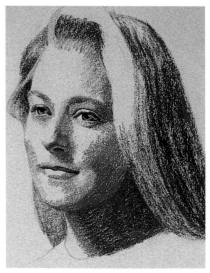

Step 1: "I make a loose pencil drawing to assess the shapes and values of the model's face," explains Caporale.

Step 2: "With a sharpened NuPastel #253, I draw the shadow side of the nose, paying particular attention to the angles. A plumb line ascertains their position as I begin to draw the eyes, keeping in mind the relationship of the parallel parts. In a frontal position the eyes should be the same length and width. The width of the nose and mouth originating from the center should be equal on each side. If the face is slightly turned, these relationships need to be adjusted accordingly. Using a gentle touch, I draw not only the components, but the shapes created by the dark shadows, in a layering and weaving process comparable to sculpting."

Step 3: "Next I lay in the most vivid colors for the middle tones. This actually demonstrates the phenomenon that light 'bleaches' the color and shadow darkens it, but the area in between remains pure. I cover the middle-tone areas with warm colors through the cheeks and mouth, ochre and umber colors on the forehead and chin. I select a local color for the eyes, which can be modified with cast shadow, and accent the pupil."

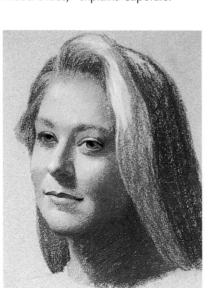

Step 4: "A good working method with pastel is to make the shadows slightly darker than they appear. Then you can continually build upon them while maintaining color in the lights and unison in the darks."

Hands

Whether or not to include hands in a portrait is an important consideration. They can be problematic, drawing attention from the head and appearing unnatural or out of place. Placing the head at the top and the hands at the bottom creates a somewhat triangular effect, which can interrupt the flow of the portrait. Also, because they repeat the approximate colors of the face, hands command attention. Many portraitists solve this problem by giving them secondary importance. Every knuckle and finger need not be carefully drawn, and often minimal attention to the hands is enough to state their form in a way that will impart grace and beauty to the portrait.

Drawing Your Own Hand

One of the best ways to learn how to draw hands is by using your own hand as a model, as Greg Biolchini demonstrates here. His emphasis is on modeling structure through values.

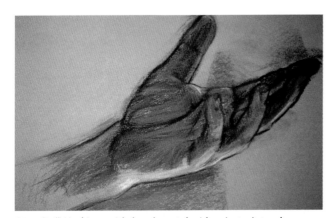

Step 1: "With vine charcoal and several sheets of sand-colored Canson paper clipped to a board to make a cushioned ground, I begin by drawing my hand from a mirror in front of me," says Biolchini.

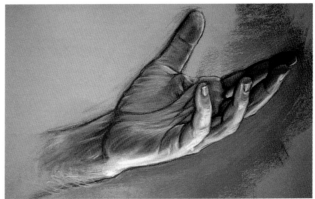

Step 2: "I use a sharpened Van Dyck brown NuPastel. When shadow shapes are simplified, I redraw with a darker burnt umber pastel stick over the Van Dyck brown and make the necessary corrections."

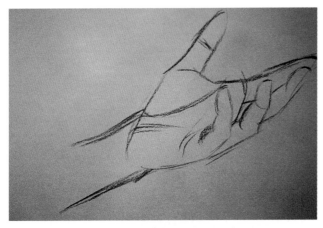

Step 3: "Working with hard pastels, I begin to introduce color into the darker value. I block in some of the reds, working with colors that are a little darker and richer than they appear. As I lighten colors, they will become duller. I cover the hard pastels with soft pastels as I work from dark to light."

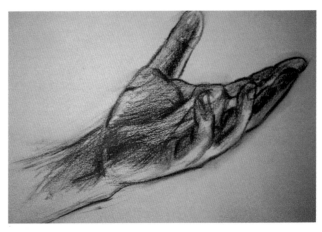

Step 4: "Paying attention to halftone colors, I work up the values in the darks, then the midtones, and move to the lights, which are put over the medium values. I aim for making the hands look natural, as nothing will ruin a portrait faster than poorly painted hands."

Drawing Hands in an Unusual Pose

Alex Piccirillo, in a bold and expressionistic technique, draws a pair of hands crossed at the wrists, strongly and structurally developed to show form and color.

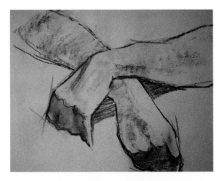

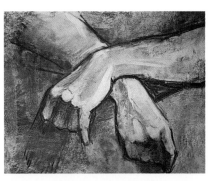

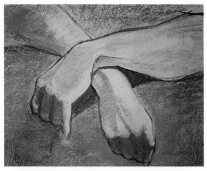

Step 1: "I begin by having the model take various poses with his hands," Piccirillo explains. "A pose with crossed wrists sets up an interesting composition. Using soft charcoal on Canson paper, I set up all the angles and block in the dark forms. I pull out the light areas with a kneaded eraser."

Step 2: "Paying close attention to the angles of the knuckles in relation to the side planes of the hands, I begin to define the veins and sinews running across the top plane of the hand. A halftone is added behind the hands to help lift them off the paper slightly and help me set up my color. After the charcoal drawing is fixed, I begin the color."

Step 3: "The color is blocked in all over. When I chose the model, I noticed his warm, ruddy complexion. An old piece of green material complements the warm colors, and his purple shirt complements the upper part of the picture. Warm ochres and reds and cool greens relate well to each other. A dark umber strengthens the angles of the wrists and arms."

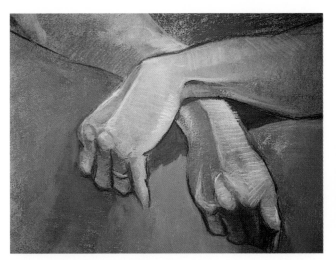

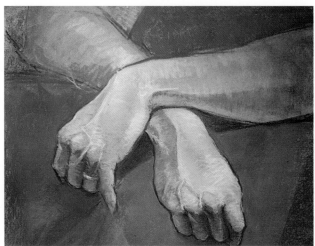

Step 4: "Refixing and redrawing, I sculpt the fingers and veins and add darks under the knuckles. I add color all over. I run both warm and cool colors together to try to create the illusion of being stretched over the bone and tissue. The knuckle area seems to be a very warm red, while the flat top part of the hand runs slightly cooler."

Step 5: "I rework the entire picture to relate all the elements, add greater definition to the veins and sinews, and polish the image with the addition of ochres, light reds, and cool greens."

Hair

To make hair look real, the artist must create a look of texture without drawing hundreds of little hairs. Hair should be treated as a mass that has planes of light and shadow. Its shape is dependent on the shape of the head beneath, and the transition between hair and face must be gentle, continuing the lights and shades of the face. Hair compliments a face in the same way a frame enhances a picture, and simplicity is often the best approach.

Integrating Hair with the Background

Claire Miller Hopkins shows how light, shade, and texture can be treated and integrated into the background colors.

Step 1: "On Canson paper," begins Hopkins, "I sketch the model with vine charcoal because it affords an easy transition to pastel. I use the charcoal only in the areas of shadow, separating the large patterns of dark and light."

Step 2: "Using dark brown and medium ochre NuPastel, I block in the dark and light passages. This thin layer creates a base to begin layering soft pastel. Using the ochre pastel, I restate the movement of hair in light."

Step 3: "I begin to layer colors in shadow areas and background. A mid-tone flesh color is repeated in the lights of the hair to create a transition between face and hair. Charcoal restates the hair's directional lines."

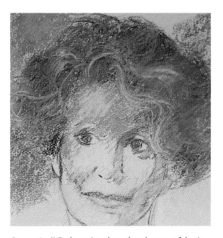

Step 4: "Colors in the shadows of hair and in the background are light and dark blue-gray, blue-green, dark and medium flesh, and medium red. The light blond color of the model's hair is used in the skin for integration."

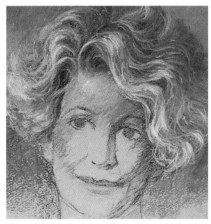

Step 5: "The playful quality of the hair makes it difficult to avoid bright light all over the head as loose strands pick up some soft lights even in the shadows. The curls pick up highlights of warm, creamy yellow."

Treating Highlights in Red Hair

In this demonstration, Hopkins makes red hair come to life by using complementary colors—in this case, olive green and blue-green—to make the reds vibrate. Notice how she handles the hair as a mass, adding lines to indicate a few individual hairs.

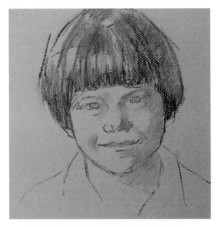

Step 1: "On Canson paper with vine charcoal, I sketch the model," says Hopkins. "Because I visualize the hair as a solid shape, I block it in with two values. As I squint to see the patterns of light and dark, I put in a few lines to indicate the direction of loose hairs. The light source is from the above right."

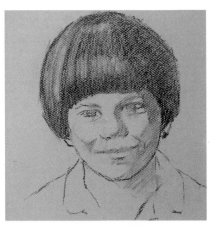

Step 2: "With hard pastels in two values, I reestablish the light and dark hair patterns. I subdue the lights and save the highlights for later. A two-value color transition works well as you convert from charcoal to color. I want to keep the solid feeling of the head and keep simple patterns."

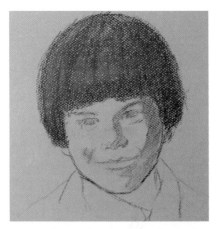

Step 3: "Using Rembrandt soft pastels, I block in the local color of the model's very red hair, using dark reddish-brown for the shadows and a medium-value red for the lights. Olive green is a cool complement. Maintaining simple shapes, I pull the green across the hair in a diagonal pattern."

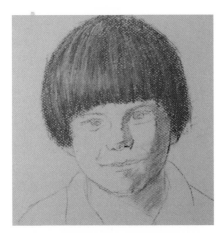

Step 4: "Keeping the darks of the hair thinly painted, I layer pastels into the large light areas. After determining the direction of the hair, I stroke a lighter value of red over the light area in a vertical pattern. Strokes of olive green are added as I work to maintain a loose, jagged hairline."

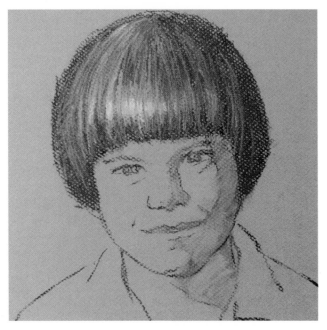

Step 5: "I introduce a medium blue-green pastel and two to three values of light red into the highlights. Individual hair strands are stroked with red, green, and blue-green, and are pulled into shadow areas. Scumbled olive green cools the reds in the shadow. A very high value of peach forms the highlights, and I place a few strokes of blue-green and olive over and into the highlighted area."

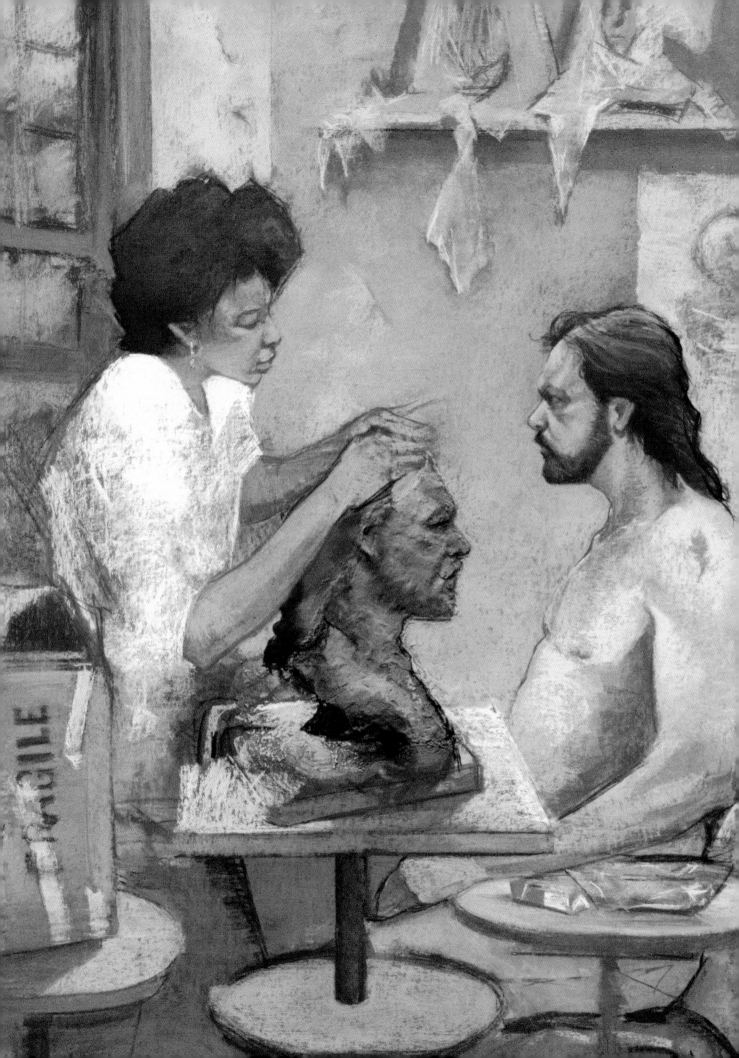

Six

CAPTURING MOOD AND PERSONALITY

The pastel portrait artist undertakes the task of trying to capture a likeness as well as create a beautiful composition. Balanced values, interesting texture, good color harmony, and a graceful design are not enough. The painting must also display character and emotion to communicate an extra dimension to the viewer, an intrinsic something that defines particular facets of the model or models.

This can be accomplished through body posture, gesture, or a particular facial expression. It may be that a face inherently has strong character lines, noble features, or a tilt of the head that communicates strength, strong emotion, aloofness, or inner power. Or the sitter may have a relaxed posture or easy smile that conveys friendliness or good humor. Dramatic lighting may be used to charge the scene with excitement, or soft lighting to give it warmth or serenity.

This chapter will show single portraits and demonstrations with strong gestural components, done by vastly different portrait artists. Each works on a different support material in a signature style.

In Progress
Alexander Piccirillo
Pastel on sanded luan wood,
60" x 40" (152.4 x 101.6 cm).
Collection of the artist.

Emotional Expression and Mood

Portraits that show discernible emotion and expression elicit a wide range of responses from viewers. The following portraits represent a departure from the formal portrait in which the sitter is seated or standing in a frozen pose. Instead, they make a statement, portray a mood, or picture or catch subjects in the act of being human. Notice especially how the pose and lighting create an impression of the subject's character.

ROBERT
Albert Handell
Pastel on sanded paper,
dry mounted on
acid-free 4-ply ragboard,
22" x 16" (55.9 x 40.6 cm).
Private collection.

In this lightstruck portrait, a long-haired black man looks quizzically over his left shoulder. Handell keeps the range of values and colors to a minimum. The lights, shadows, and compositional rhythms are complimented by the rough, partially covered surface of the background. The frontal position of the body, with the head turned in another direction, adds movement and strength to the portrait. The light cast from the upper right washes over the figure, causing glowing folds and shadows on the shirt. The diagonal position of both arms serves to keep our attention on Robert's face.

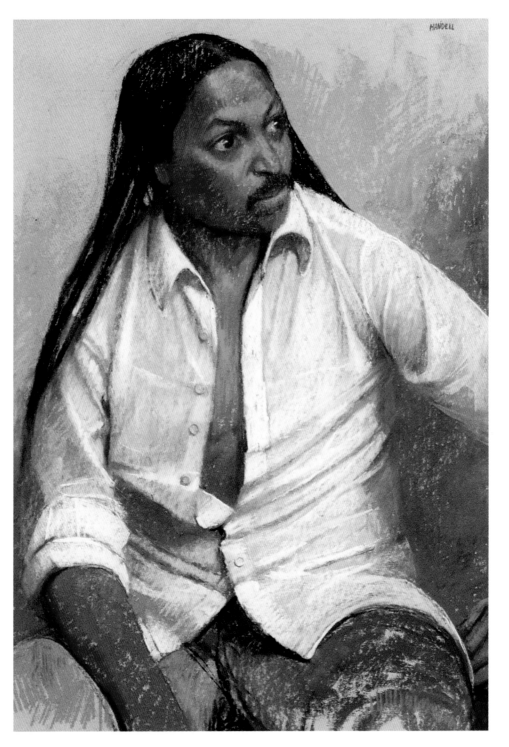

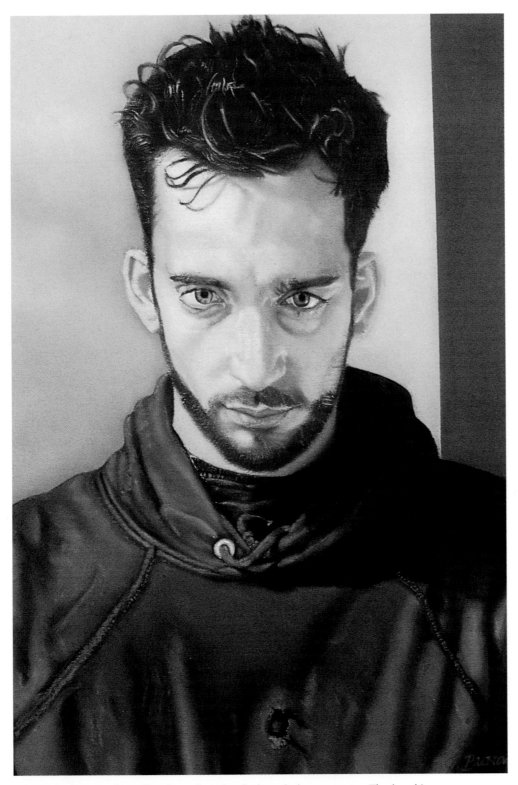

ETHAN
Jonathan Bumas
Pastel on paper
prepared with acrylic
and quartz crystals,
22" x 15" (55.9 x 38.1 cm).
Collection of the artist.

Ethan is an intense, brooding frontal study of a bearded young man. The head is lowered, the eyes looking up are slightly asymmetrical, and the viewer is engaged by the hypnotic, slightly fatigued eyes of the subject. The simplicity of the background, with its vertical black stripe, repeats the color of the hair, eyebrows, and beard. The navy blue hooded sweatshirt directs the viewer's gaze back to the intensity of the face.

GRIEVING—MA II
Claire Miller Hopkins
Pastel on sanded paper,
22" x 14" (55.9 x 35.6 cm).
Collection of the artist.

The mood of the subject is readily apparent in this striking portrait of a grieving widow in her nineties. Loss, sadness, and the rigors of old age are written on her features and easily communicated to the viewer. In the elderly, the areas around the mouth are not well defined. Short vertical strokes are used to keep the lines of the mouth soft. Hopkins uses charcoal to rework the line between the lips and soften the expression. "Yarka pastels are marvelous on this paper," says the artist, "allowing feathering, correcting, short choppy strokes, and the building of layers."

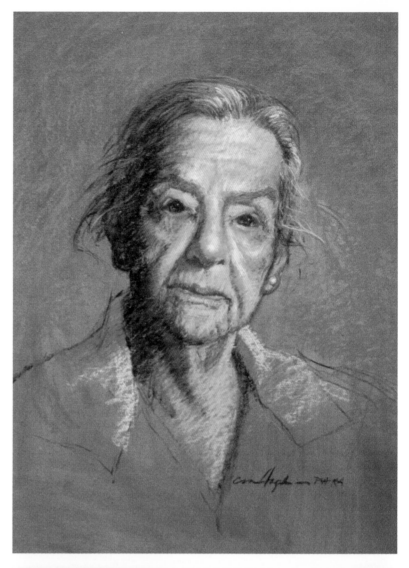

In this detail, the layers of overlapping strokes are evident with their constant interplay of warm and cool. The textured surface creates the look of aged skin. Note the sensitive treatment of the mouth with creases in the lips.

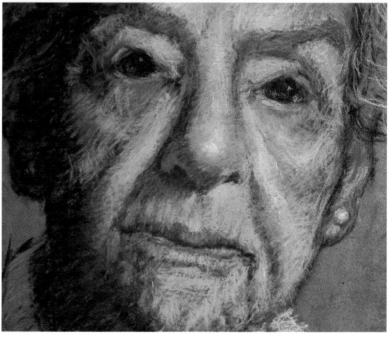

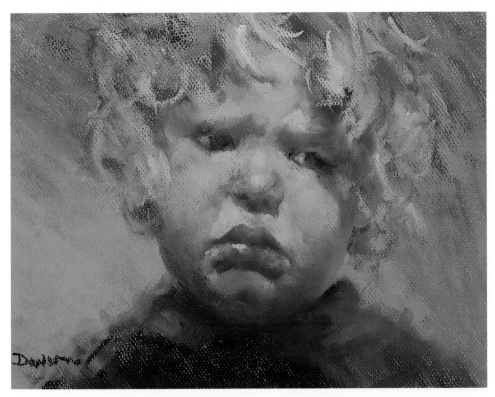

TIM ROY
Doug Dawson
Pastel on paper,
10½" x 13½"
(26.7 x 34.3 cm).
Collection of Mr. and Mrs.
Steve Patterson.

Little Tim's face displays a universally recognized mood. The quivering lips, red nose, and tearing eyes convey a feeling easily read by the viewer. He is an unhappy little boy, and Dawson has accurately captured that emotion in the colorful, textured portrait. The strong diagonal stroking from the upper left to the lower right compliments the downcast eyes.

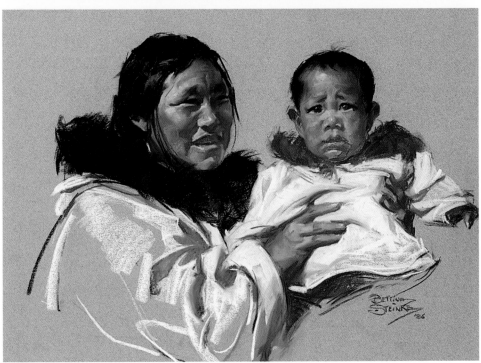

PRIDE AND BEWILDERMENT
Bettina Steinke
Pastel on paper,
18" x 24" (45.7 x 61 cm).
Private collection.

The title of this glowing pastel of an Eskimo mother and her infant aptly names this fine example of Bettina Steinke's beautiful portrait work. Nothing is overstated, but each figure captures character and expression, so that the viewer wants to smile too. The clothing, though simply stated, has realistic texture on the fur collars, and the white material of the clothing has well-developed folds and creases. The palette for the brown and ruddy complexions is skillfully chosen. There is great authenticity to the drawing in this pastel painting, and the expressions strongly reiterate the title.

Exhaustion

Rhoda Yanow, a New Jersey artist, portrays an exhausted ballerina of the New Jersey Ballet Company during a long and arduous rehearsal. She shows the dancer sitting on the floor to recuperate, holding her foot with one hand and perhaps rubbing her neck with the other. The body position and facial expression convey the weariness of the model.

Step 1: "Starting with the contours of the head, hair, neck, shoulders, and body," says Yanow, "I begin to work lightly with NuPastel #333P, a color that blends beautifully with flesh color. I indicate the shape of eyes, nose, mouth, and ears."

Step 2: "I use NuPastel #223 dark brown for the shadows. Correcting my drawing, I work on the face, neck, shoulders, and body."

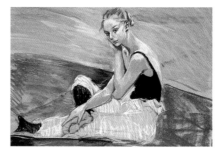

Step 3: "To rough in highlights at this point, I use NuPastel #276, which is a useful color. I always have to control the lightness, or chalky highlights result."

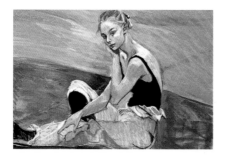

Step 4: "Halftones are put in the eye sockets, on the nose, and where light and shadows meet on the forehead, neck, and chin. Values are continued on the clothing and background. I try not to get lost in the painting process —I want to convey the dancer's frailty as I catch her at a moment's rest."

THE BALLERINA
Rhoda Yanow
Pastel on paper,
19½" x 25½"
(49.5 x 64.8 cm).
Private collection.

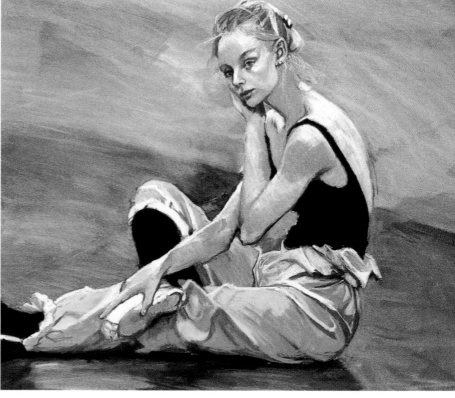

Step 5: "In the leg area, note the direction of strokes and the admixture of pastel colors. I finish the rough black leotard and leg warmers and turn my attention to the semi-transparent nylon pants. I work over all of the painting, pulling the parts together. I think that I have captured the look of an exhausted dancer after a lengthy rehearsal with workout clothing clinging to her body."

Rest

Alexander Piccirillo uses bright pastel colors to catch the peaceful mood of his wife, Phyllis, taking a nap. He has managed to capture the complete relaxation of a body at rest. Piccirillo works on luan plywood primed with several coats of a mixture of gesso and ground pumice stone. The ground coat is a wash of permanent green and raw umber.

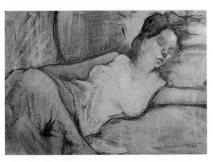

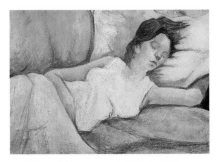

Step 1: "After massing in the shapes with soft charcoal and pulling out the light areas with a kneaded eraser," Piccirillo explains, "I block in color all over the board. This leaves me with some compositional problems because all the color is close in value, so I have Phyllis pose again. Adjusting my light source seems to separate the pillow from the sofa and the blanket from the figure.

Step 2: "More detail is added to the face, and heavier color applied all over. Light turquoise blues are added to the shirt, and warm pinks to the pillow. Several shades of brown and blue are painted in the mass of hair. I am simplifying form as much as possible to keep the attention on the sleeping face."

Step 3: "Once I have Phyllis posing again, I am able to change and resolve some parts of the picture. I redesign the pillow, adding darker, cooler purples and grays where the head is resting. Further changes are made on the body and on the cushion that bends beneath the figure."

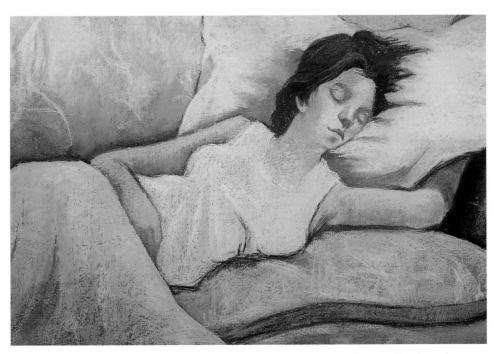

AFTERNOON NAP
Alexander Piccirillo
Pastel on sanded luan wood,
24" x 40" (61 x 101.6 cm).
Collection of Mr. and Mrs.
G. E. Angelo.

Step 4: "Cooler blues and green cool the sofa again. I add pink and green floral touches, taking care that they don't detract from the figure. Because the colors are still close in value, I add cooler greens and pinks to the model's face and arms. The hair is reworked with umbers, blue, and light gray. With a few added touches, I bring the painting to a close."

Reverie

In this demonstration, I use facial expression and an impressionistic background to capture the pensive mood of my subject. As the girl examines some red flowers in a garden, she seems lost in a childhood reverie. I work on museum board surfaced with pumice and gesso. I apply an underpainting of acrylics and a wash of burnt sienna.

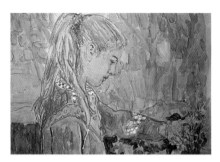

Step 1: Working from the live model and photographs, I lay in the drawing in charcoal and fix it with a thin line of burnt umber acrylic. I cover the drawing with a burnt sienna wash and begin developing the background with some reds, greens, and yellows.

Step 2: With transparent acrylic washes, I further develop the image with burnt umber, burnt sienna, caput mortuum, and blue-green. The organic background shapes are developed first, and I mask the figure to keep the dust from sullying it while the background is being advanced.

Step 3: The flesh colors are developed with an emphasis on working lightly and concentrating on the dark and medium values and colors. All edges and lines have to remain soft on a child. I work to correct the parts that need refining.

THE RED FLOWERS
Madlyn-Ann C. Woolwich
Pastel on handmade
pumice board,
18" x 24" (45.7 x 61 cm).
Private collection.

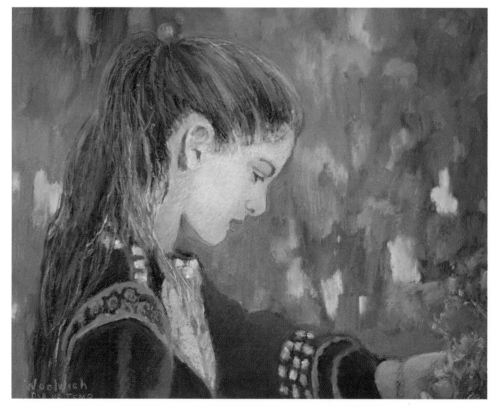

Step 4: While balancing the lights and darks in the picture, I make the final adjustments to the features and enlarge some of the red flowers. I lose many edges as I soften them and find few with definite edges. The lights and highlights are softly balanced, and I work carefully to modulate the colors and effect the seamless integration of a portrait figure into an outdoor environment.

Reflection

Claire Miller Hopkins gives a stark look to her portrait of an artist posed in front of her creation. Arms crossed and eyes cast down and to the side, she seems to be listening to someone, perhaps her own inner voice. Using charcoal and odorless paint thinner, Hopkins lays in values in what amounts to a black and beige underpainting before gradually applying color in this step-by-step demonstration.

Step 1: "Using charcoal pencil," says Hopkins, "I indicate the contours of the model and dark patterns of the composition, as well as some directional lines in the construction behind the model. Then I apply a wash with charcoal and odorless paint thinner. The dark wash saves pastel in the long run and gives me an overview of the composition to decide whether or not it works."

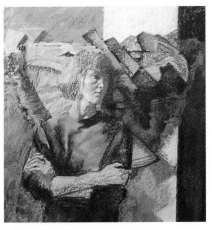

Step 2: "With small pieces of Yarka pastel, I spot color around and begin to design the kite-like construction behind the artist. The colors are dark blue-gray, red, blue, ochre, gray, and olive green in an unlimited value range. I redefine the image with charcoal, reducing the size of the arms and hands of the model. With Sennelier and Rowney pastels, I work up the shapes of the wall piece."

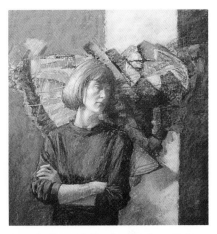

Step 3: "I carefully observe how light follows the form. The model has a beautifully angular face that is great to draw and paint. In completing the piece, I balance the lights, layer shapes, and do fairly detailed work on the background construction."

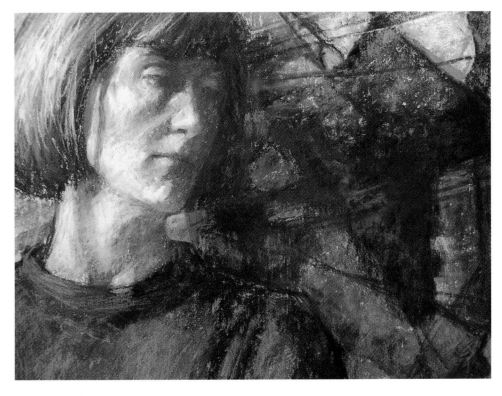

Step 4: "This detail shows the loosely scumbled texture of the construction behind the model. Because it is a three-dimensional piece, the very soft pastels, lightly scumbled, help create a feeling of depth. Fine detail in the hair is created with Yarka pastels."

THE ARTIST (DETAIL)
Claire Miller Hopkins
Pastel on Ersta sanded paper, 20" x 17" (50.8 x 43.2 cm). Collection of the artist.

Self-Portraits

Sometimes an artist paints a self-portrait to record his or her own image, but more often the self-portrait is done as an exercise to master a particular skill or technique. The model is always available whenever you want to practice drawing hands or facial features or try out new colors.

Painting a Mirror Image

Rhoda Yanow, in a compelling self-portrait, meets the difficult challenge of looking in a mirror and being a model for herself. Working in bold strokes, she keeps her colors to a minimum and captures herself in the role of being an artist.

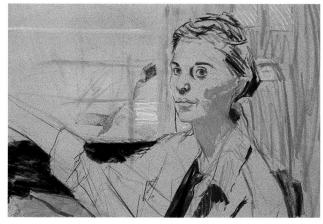

Step 1: "With a mirror hooked up to the right side of me and the light emanating from a work lamp on my right side," notes Yanow, "I lay in the drawing with a sharpened NuPastel."

Step 2: "Glancing frequently in the mirror, I see characteristics of my parents' faces in my own. I continue working the shadow sides with dark flesh color and use black for the darkest values."

Step 3: "The face is nearly finished with the addition of light flesh color and highlights on the forehead. The face is again modeled with darker tones, and cadmium red is added to the lips and cheeks. The shirt is worked with values of blues and grays. The background is further developed."

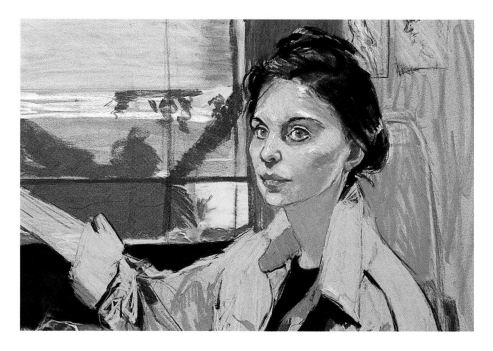

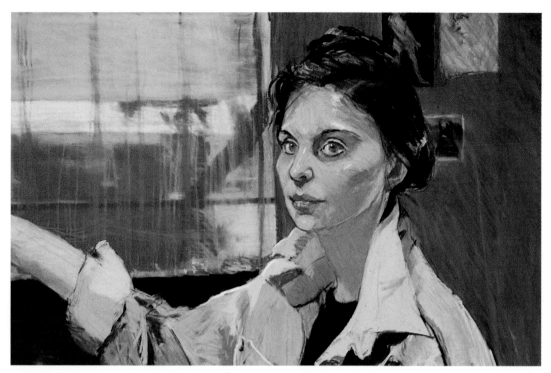

SELF-PORTRAIT
Rhoda Yanow
Pastel on paper,
19" x 25"
(48.3 x 63.5 cm).
Collection of the
artist.

Step 4: "I darken the panel to the right to bring the model forward. The shirt is completed with various shades of blue, gray, and purple. All parts of the picture are assessed and refined."

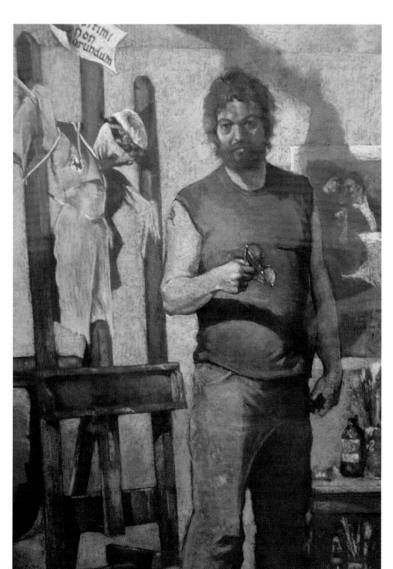

THE EFFIGY
Alexander Piccirillo
Pastel on sanded luan wood,
60" x 40" (152.4 x 101.6 cm).
Collection of the artist.

With a whimsical sense of humor, Piccirillo pictures himself as he must sometimes feel, in a pensive, self-deprecatory mood. The portrait is revealing as he stands in his small, crowded art space in the basement, surrounded by the tools of the trade: sketches, paints, pastels, brushes, and bottles. His large studio easel holds a scarecrow figure hung in effigy, bearing a humorous sign that probably reveals his thinking about the difficulties of being an artist. The textural quality and handling of light paths, combined with evocative colors, make this an exciting piece.

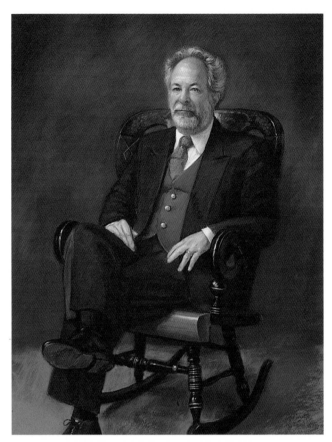

Step 4: "Having revised and corrected the face, I work over the entire drawing, reflecting and visualizing how I want the final statement to appear. Color corrections are centered on the hands, shoes, pants, and chair. The pants were crosshatched with many colors. I bring the chair with gold decorations to an equal finish and work on color to advance the front part of the shoes, pants, and chair."

Step 5: "The necktie and hands are adjusted to the level of the finished drawing. The background colors are also modified to provide enough contrast for aerial perspective."

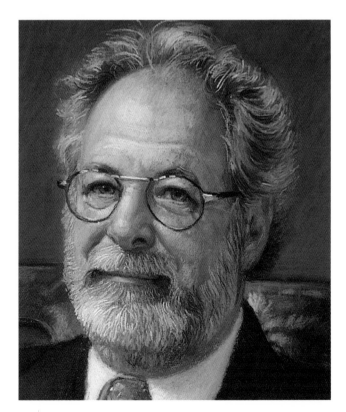

Step 6: "The proportions of the face, shown here in closeup view, are adjusted again because of constant buildup and color revision. At this point I add the glasses. The gentle impish characteristics of the sitter are becoming evident."

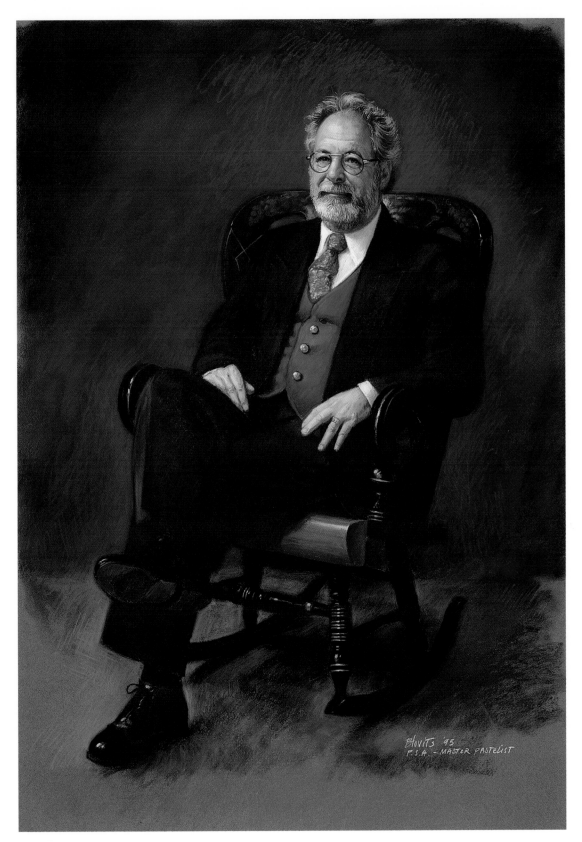

JACK DAGLEY
Larry Blovits
Pastel on paper,
41" x 29" (104.1 x 73.7 cm).
Collection of the artist.

Revealing Identity Through Clothing and Personal Accoutrements

Clothing and personal objects can be included in a portrait to make a statement about the sitter. Special clothing, whether it is a kimono, a riding outfit, or an army uniform, creates an identity for the wearer and sets up certain expectations in the mind of the viewer. Although not as obvious as clothing, personal objects—a musician's instrument or a sculptor's artwork—can serve the same function. The artist may give clothing or personal objects exaggerated importance because they help the viewer to know something more about the model.

When it is not a special outfit, clothing that is simple, natural, and familiar for children and beautiful and complimentary for adults should be chosen. Draping folds and lush and textured materials add variety. Soft velvets, shiny silks and satins, thick and lustrous tweeds, and dramatic dark materials all impart a genuineness, which is, after all, a whole and complete picture of more than the sitter's likeness.

In this half-figure portrait of a Japanese woman, the body is facing front, but the head is slightly turned, giving the figure grace, serenity, and an easy posture. The lustrous flesh colors are reiterated in the salmon silk of the kimono. The creases and folds of the silk robe are rendered convincingly, and the texture of the obi or sash is easily visible. The background is an echo of the colors used in the flesh and clothing of the model. This adds great unity to the portrait. While the graceful lost and found edges easily move the viewer's eye around, the Oriental mood is carefully maintained.

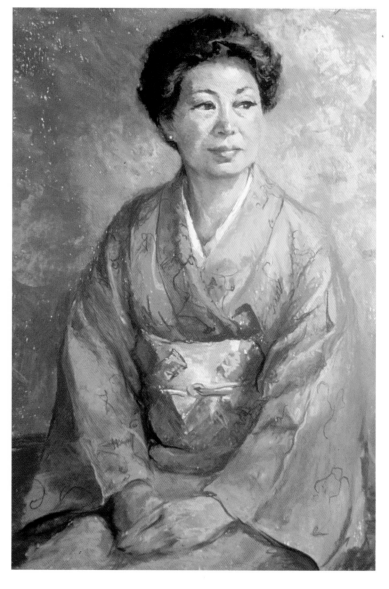

YASUKO ROBINSON
Dorothy Barta
Pastel on paper,
28" x 22" (71.1 x 55.9 cm).
Collection of the artist.

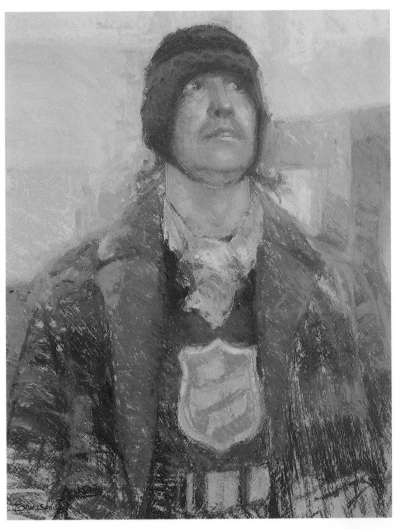

PRIVATE IN THE SALVATION ARMY

Doug Dawson
Pastel on paper,
25" x 20" (63.5 x 50.8 cm).
Collection of the artist.

Doug Dawson's quirky rendition of a man dressed in an impossible collection of clothing is a humorous statement. Underneath the fur-collared jacket, he proudly wears his Salvation Army sweatshirt. The crazy-quilt appearance of the walls behind him adds a colorful note. It is the dignity of the man's face under that silly knitted hat, the carefully constructed light patterns, and the sloping triangularity of the shoulders that fasten the viewer's attention on the man's sincere face.

THE BANJO MAKER

Doug Dawson
Pastel on paper,
27" x 25" (68.6 x 63.5 cm).
Collection of the artist.

Dawson captures the eccentric quality of a banjo maker both in the texture of the clothing he is wearing and the seedy, unshaven look of his face. The eye patch gives him the appearance of a pirate, but the incandescent quality of the banjo and his rapt attention to the sound give him authenticity. The clothing and the room are dark. The brightly lit small window and the banjo maker's face draw the viewer's attention. The handling of the light and texture in this picture knit it all together in a compelling composition.

SON OF THE EMERALD ISLE
Bettina Steinke
Pastel on paper,
23" x 19" (58.4 x 48.3 cm).
Private collection.

This vignette of a man looking straight at the viewer through shadowed eyes is a lesson in never overdoing a painting. Steinke outlines her subject's hat and lets the paper act as a middle tone. The textural clothing is alluded to, but the careful development and the contrasting values are saved for the face and the collar that surrounds the neck. The brim of the hat casts a defining shadow across most of the face.

The glowing flesh tones are beautifully painted, whether they are in shadow, in light, or highlighted. From the texture of the hair and beard to the fabric of the coat and shirt to the cigarette clenched in his teeth, all parts have a tactile quality that shows the easy expertise of the artist.

THE ELDER
Foster Caddell
Pastel on paper,
20" x 24" (50.8 x 61 cm).
Collection of the artist.

Foster Caddell, ever the master of the understated vignette, paints a luminous portrait of an elderly man smoking a pipe. In his work Caddell often refers to "the drama of light and shadow." This brightly lit profile portrait with its cool shadows is a good example. The head is strongly delineated, with rough and tactile textures in the hair and beard. The simply drawn hat and the vivid shadow patterns make this an outstanding example of simplicity and great talent.

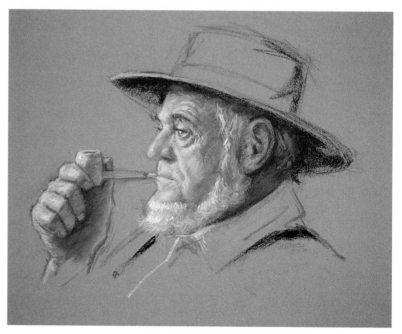

Recording a Detailed Costume

When Foster Caddell attended a Scottish festival in Scotland, Connecticut, and saw the drum major, he knew he had found a painting subject. The impressive military bearing and dignity of the man made him "a portrait waiting to be done."

Caddell faces a few artistic challenges in creating this portrait: balancing a uniform that is equal in importance to the face, dealing with a face-obscuring helmet, and achieving luminous flesh tones while keeping the lightest parts darker than the white helmet and jacket. Using a wooden mannequin with an intricate ball-and-socket joint system, he has a stand-in when the model is unable to be present.

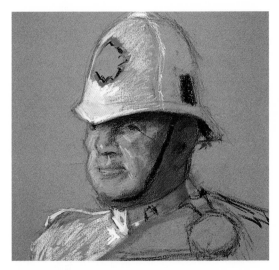

Step 1: "I model the head as I would a sculpture," says Caddell, "with color and value. Eschewing large flat strokes, I proceed with many small strokes, exploring color possibilities. I place a simple passage of red in the plaid sash to help me achieve correct color and value in the face."

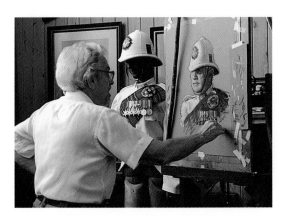

Step 2: "The intricate details of the uniform take much time. Fortunately, I have a wooden mannequin with ball-and-socket joints that can be put into any position. Here I'm working from it in the studio, saving the model hours of posing."

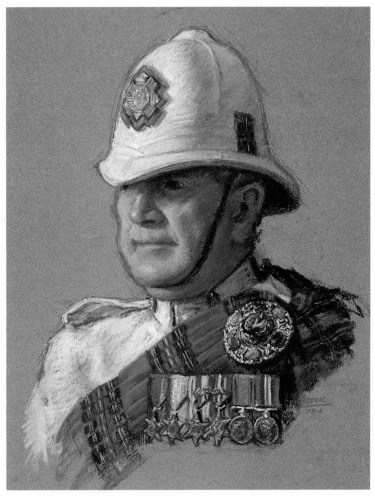

Step 3: "In the absence of the model, I incorrectly drape the sash with the pleats upside down. I have to scrape it down with a razor blade and redo it. Notice the various ways I handle the pastels, from the softness of the face to the pointillism in the jeweled brooch. In the helmet I introduce as much color as possible and still have it look like basic white. In my work I repeat a bit of every color throughout the composition to ensure overall harmony and unity."

THE MAJORDOMO
Foster Caddell
Pastel on paper,
21" x 17" (53.3 x 43.2 cm).
Collection of the artist.

Abstract Backgrounds

An abstract background allows the artist to set off the figure with color or shapes. In *Girl with a Kite* on page 106, Daniel Greene has patterned the background with a dark blue-black band that echoes in the clothing and helps relate the colors to one another. The ochres, reds, and bluish blacks are repeated in the woman's smock. Careful analysis will reveal integration of most of the portrait colors into the background. In Greene's portrait below, the abstract rectangular shapes in the background repeat colors from the figure but contrast with her willowy posture.

LOOKING UP
Daniel E. Greene
Pastel on granular board,
48" x 24" (121.9 x 61 cm). Collection of the artist.

Daniel E. Greene creates a mood portrait with Rembrandt lighting, in which the warm dark background joins the figure's hair and mysteriously moves her into shadow. The cool, radiant features of the model are incandescent. The light patterns bounce from the features to the front part of her ruby shirt, which is darkly shadowed for dramatic effect. Ochre, yellow, and red horizontal bands across the picture add a hopeful note. Could the young woman be looking at the moon? Wishing on a star? Looking at constellations?

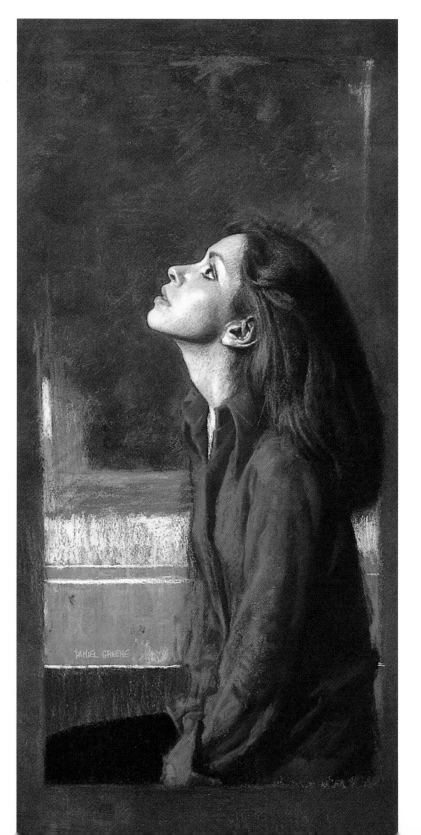

Flat, Textured Backgrounds

A flat, textured background can be effective in giving dimension to the portrait's main figure or figures. Although the background may show objects, they are painted in low or even flat relief so that they provide texture but don't detract from the subject of the portrait. For maximum effect, the colors should be close in value and hue, but it is important that the colors be picked up from the main subject to give the painting good color harmony.

ANA AND JULIA
Bob Graham
Pastel on sanded board,
30" x 36" (76.2 x 91.4 cm).
Collection of Dr. and Mrs. Gustav Coutin.

This sunny portrait of two sisters in their very best fancy blue dresses is an excellently composed picture. The tree and fence in the background, with a strip of blue sky, are visible only upon close inspection and form a textured warm backdrop. The blues of the dresses are laced into the umber of the tree and fence to promote vibrant tonalities that suggest subtle qualities of light. The patterned qualities of the lace and the discernible nap on the velvet dresses, along with the brightly bounced light patterns, combine to make a three-quarter portrait of great charm.

POPS
Gregory Biolchini
Pastel on pumice board,
24" x 40" (61 x 101.6 cm).
Collection of the artist.

In this high-key portrait of an elderly man squinting into the sun, textural qualities are carefully evoked to add authenticity to the image. The hair and beard are carefully worked to give depth and color. The artist repeats the hair colors in the mortar of the brick background. The man's ruddy complexion and the light and shadow of the flesh colors are repeated in the bricks, while the vibrant pink shirt and the shiny light tan jacket are repeated in the lights of the bricks and mortar. The arrangement of the dark shapes of missing bricks surround and compliment the figure to keep attention on the focal point.

Elaborate Settings

Sometimes the portrait artist will include a complex background and numerous props to create a mood or show an activity, as the examples on this page show. The trick is to do this without detracting from the main subject of the portrait. In both of these paintings, the objects are painted realistically, but Larry Blovits has obscured some parts of them in darkness and used light to give his subject importance. Marbo Barnard has kept her subject prominent by placing her center stage, engaged in an activity, and using light values to attract the eye to the figure.

DAWN
Larry Blovits
Pastel on paper,
26" x 40" (66 x 101.6 cm).
Collection of the artist.

In this three-quarter portrait illuminated by cool light, the subject emerges from a dark Rembrandtesque background that reveals how well Larry Blovits can control value and edge. The raised quality of the crocheting on the sweater, the velvet skirt's texture, and the net stockings add information about the woman's surroundings. Other interior textures include the shiny smoothness of the plant leaves, the nap of the green velvet sofa, and the subdued opalescence of the glass and metal table lamp. Note the principal lighting on the face and upper body and the subordination of the light values on the hands.

CANDY APPLES
Marbo Barnard
Pastel on sanded paper,
28" x 22" (71.1 x 55.9 cm).
Collection of Jens R. Larsen.

In this portrait, a young girl in a candy apple store is busy doing her job, but she is lost in day-dreaming. Barnard says, "Part of my objective was to catch the mood of the girl and the background reflections through the glass window, which seemed to go on forever." The action of the girl, her costume, the store background, and the objects all contribute to the portrait's overall impression of capturing a moment in time. Notice how Barnard has rendered the various textures of wood, cloth, and metal.

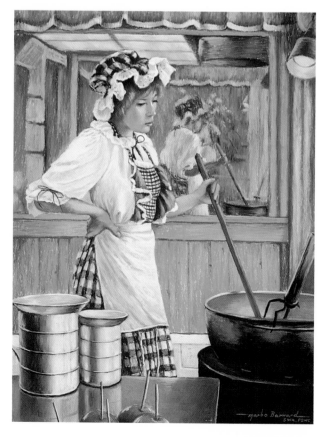

Letting the Setting Tell the Story

Marbo Barnard photographed the model for *Tea Ceremony* in her studio. After two sessions she selected three possible poses and sketched them out before making her final choice. Traditionally, a Japanese woman in a kimono would never be placed on a chair or bench; the sitting position on a tatami mat is an integral part of the ceremony. Not having a full-size screen to use as a prop, Barnard used a miniature screen and expanded the detail to painting size. She works with hard and soft pastels on Ersta sanded paper bonded to acid-free museum board.

Step 1: "After I work out the proper placement of proportions and individual features of the model's face," Barnard explains, "I start the background underpainting. I use olive green and gold ochre to create the base for the gold leaf screen and dark colors in the facial features and hair."

Step 2: "Next I work on the cool and warm shadows on the face, the darks in the hair, and the shadowed side of the kimono. Peony blossoms are developed and green added to the leaves and plant shadows. The background is complete."

Step 3: "I work out the tone and color in the shadowed side of the face and apply warm and cool colors in broken strokes throughout the face. With the natural progression of working from left to right, I work on the teapot with grays, umbers, siennas, black, and blue. The features are softened and modeled to determine their final shape and value, and I add highlights. Other parts of the picture are worked to completion."

Step 4: "I then take a critical look at the composition. The lighting and positioning of the model's right hand in the original photograph created a significant challenge in painting the hand, which I decide to redo."

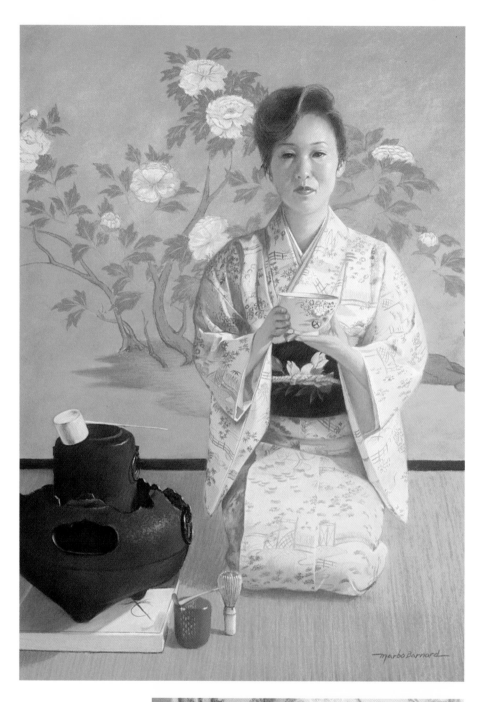

Step 5: "It has become apparent that the position of the model's right hand still looks awkward. To overcome this problem, I recall the model and reposition the angle of both the arm and the hand. This also necessitates movement of the kimono sleeve. I use compressed air to remove the pastel, then redraw and rework the corrections."

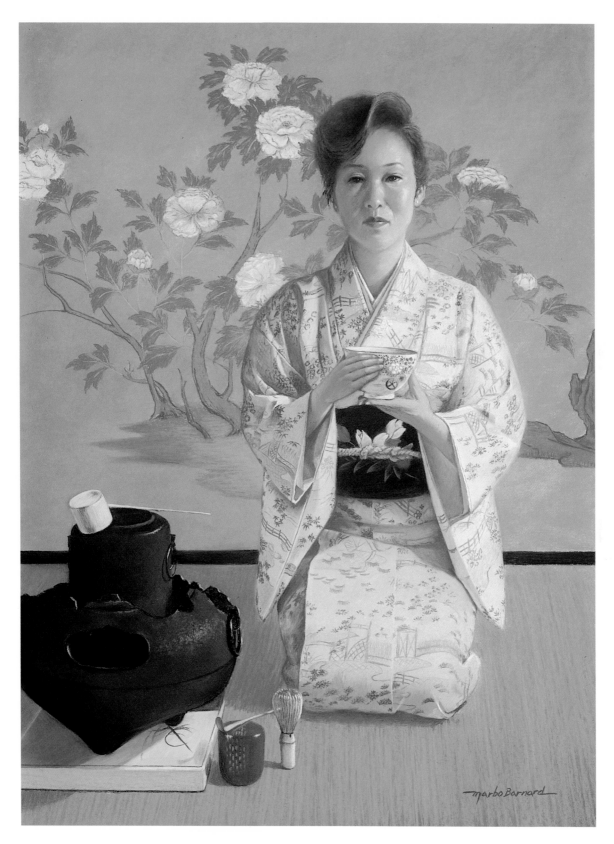

TEA CEREMONY
Marbo Barnard
Pastel on sanded paper,
28" x 22" (71.1 x 55.9 cm).
Collection of the artist.

Step 6: "With the hand and arm now in a more graceful position, I recheck the entire composition and make the final adjustments to the values of the highlights and shadows. Note the delicate strokes I use in the model's face."

Urban Settings

Using a city scene as the backdrop can add vibrancy or interest to a portrait or give it a special mood, from grim and disturbing to glittering and glamorous—anything but peaceful or serene. The city attracts all kinds of people from all kinds of places who engage in all kinds of activities. For the artist it is a treasure trove of settings that are a study in contrasts—from tuxedoed musicians playing in a nightclub to street musicians playing in a park; from elegant women shopping on Fifth Avenue to a homeless woman scouring a trash bin. As shown in Tim Gaydos's demonstration below and in Daniel Greene's portrait at right, the city also has a special kind of light that is not found elsewhere.

Adding the Background After the Figure

Working from sketches done on location, Tim Gaydos created this gritty urban portrait of a man trapped in society yet seeking refuge in its products. He hired a model, set him up on a blanket, and concentrated on the figure before adding the background of iron posts, hydrant, and street trash. The principal challenge he faced was painting a figure upside down.

Step 1: Gaydos placed the figure according to sketches done on the street, changing the model's position to give the hands more interest.

Step 2: He concentrated first on the face, then proceeded with the clothing. With the figure nearly completed, the artist was ready to lay in the background, which he did by referring to his original on-site sketches.

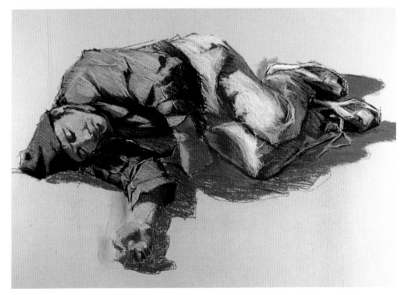

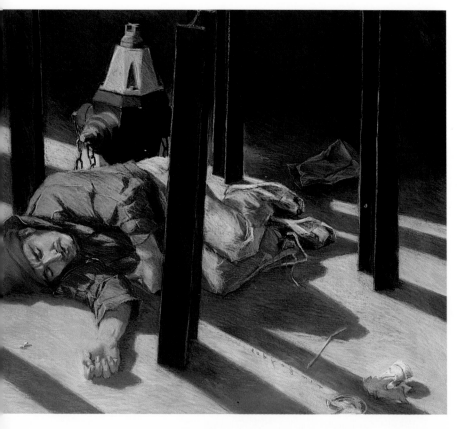

Step 3: The surroundings, a littered streetcorner with a structure of metal posts enclosing a fire hydrant, were added around the figure, creating a realistically gritty environment. The details and the entire painting were then carried to a finish—the hands refined, the mouth opened for authenticity, and the hat color changed to red to add color and draw attention to the face.

EARLY MORNING
Tim Gaydos
Pastel on wood panel with pumice and gesso,
20" x 24" (50.8 x 61 cm).
Collection of the artist.

RED TRAIN
Daniel E. Greene
Pastel on paper, 30" x 46" (76.2 x 116.8 cm). Collection of Mrs. Sandra Miot.

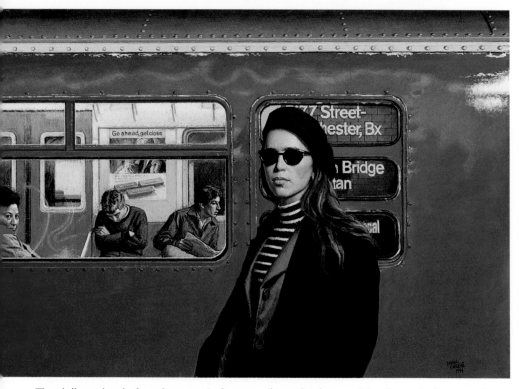

The dull, cool red of a subway train forms a vibrant background for the main figure and becomes a frame for the weary passengers. The young woman's gaze, direct and frontal, is hidden by black sunglasses. Greene has made good use of the dark values of blacks and browns. He uses them in the young woman's clothing, hat, and sunglasses, the sign on the outside of the train, the interior of the train, and the passengers' hair and clothing.

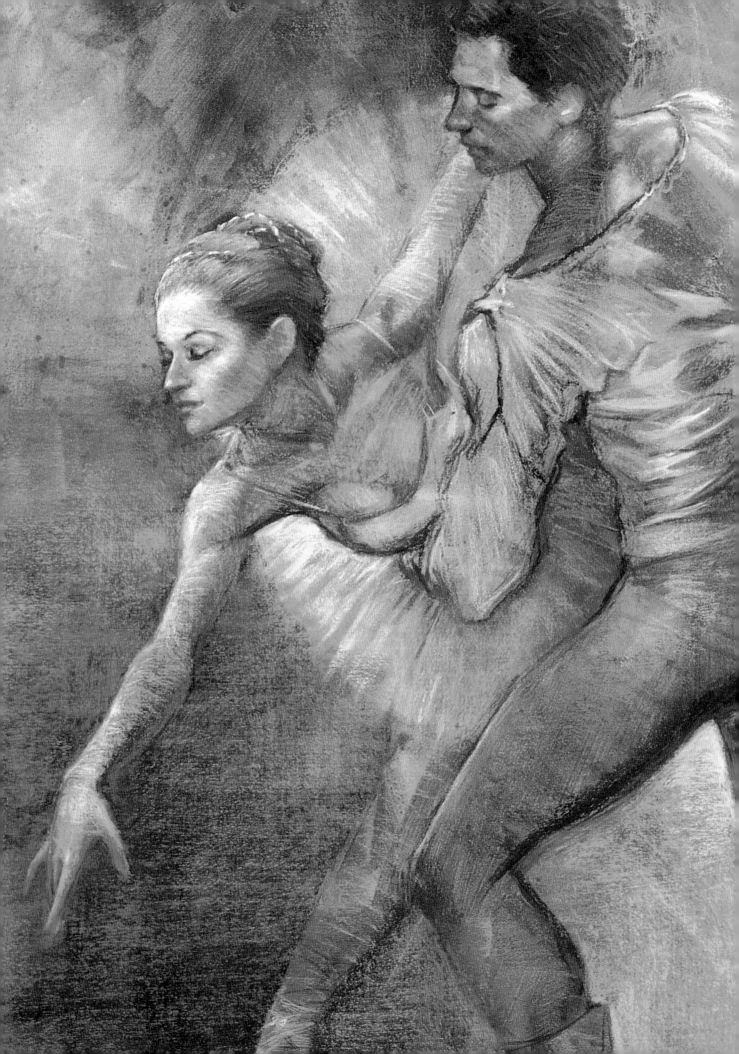

MULTIPLE-FIGURE PORTRAITS

Often the portrait artist is faced with the challenge of painting two or more figures in a portrait, especially if it is a commissioned work. Families want to be painted as a group, parents decide to have their children painted together, or a couple wishes to preserve a wedding day or special anniversary. Sometimes a subject will decide to pose with a pet, which is, after all, not a prop but another living figure.

Many of the ideas presented in earlier chapters about backgrounds, posing, lighting, and composing can be applied to the multiple-figure portrait. But the inclusion of more than one figure also presents special considerations, especially concerning the relationship of the figures to each other. How do you divide the space on the picture plane to accommodate the figures, how do you relate the figures to each other, which one do you make dominant, how do you achieve balance? The portraits and demonstrations in this chapter offer some solutions.

THE BALLET DANCERS (DETAIL)
Gregory Biolchini
Pastel on pumice board,
30" x 24" (76.2 x 61 cm).
Collection of Mrs. Helen Alkire Collins.

Double Portraits

In a formal double portrait, the artist is concerned with capturing a good likeness of the subjects and creating a balanced composition. The opportunity to depict the relationship between the two figures is limited by tradition. The informal portrait, however, offers the artist the opportunity to make the relationship between the two subjects the main focus. In the demonstration by Claire Miller

Hopkins on pages 119–120, the psychological interaction between the two girls is evident even though no activity is depicted. We see it in the pose, with one head facing out, and in the facial expressions. On the other hand, in the demonstration by Tom Sierak and the portrait by Wende Caporale, an activity is used to express the love between mother and child.

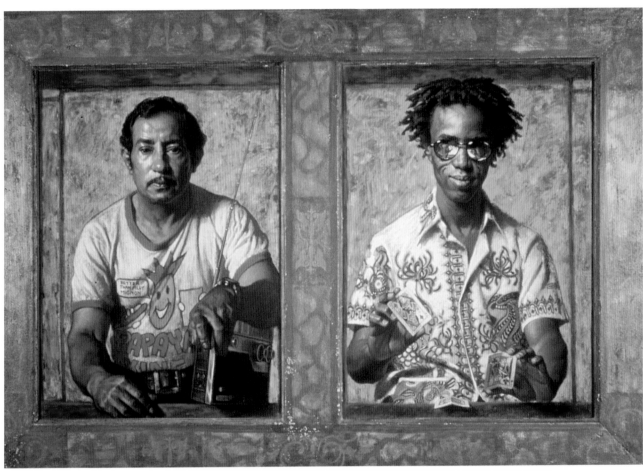

THREE CARD MONTE
Daniel E. Greene
Pastel on paper,
29" x 21" each
(73.7 x 53.3 cm each).
Collection of Mr. and Mrs.
Paul Goldenberg.

This diptych, mounted on a patterned pastel background, is a study of diversity, or "giving character to the character." With hands seeming to come out of the frame, each man meets the eyes of the viewer in a direct gaze. The Hispanic man, in his brightly decorated baseball shirt, sits benignly with his antennaed radio tucked beneath his arm, probably listening to a baseball game. The black man, with his Rastafarian curls, blue-tinted glasses, and embroidered shirt, would be right at home in the Caribbean. He is demonstrating his prowess with cards, and his expression beckons you to join him. The color red is bounced into the shirts, frames, faces, cards, and background. The flesh tones are dark and luminous. This is obviously done to evoke a humorous response, as the unlikely duo, side by side, could put a smile on the face of a statue.

Portraying the Connection Between Two Friends

This portrait depicts a close relationship. Even though there is tension between the two girls, they find it hard to separate. As Claire Miller Hopkins explains, "To enhance the feeling of unease or tension between the girls, I place vertical bands at left and right, with taut diagonal strings between them. My aim is to place the two figures comfortably within the rectangle. They are pushed together in the center of the composition and held there by vertical bands of shadow. The background is designed to support and present tension."

Many pastel stroking techniques are included: large areas with the side of the pastel and diagonal, vertical, horizontal, and crisscrossed lines. These bring elements toward the light and present more detail. There is less detail in the shadow patterns.

Step 1: "I tentatively place the head and shoulders of each girl," says Hopkins. "The Ersta sanded paper is stained with burnt umber and burnt sienna oil paint thinned with odorless paint thinner. The general proportions of the figures are indicated."

Step 2: "Reconsidering the placement of the figures, I remove the initial drawing. One girl is moved higher to bring the figures closer. I then lay in the dark pattern on the heads and shoulders and suggest a large connecting shadow behind the girls. Placement of the features is worked out. The pattern is restated with dark raw umber. Vertical and horizontal lines are suggested in the background."

Step 3: "The subject is tension between friends. Dramatic lighting and intense or rich color will heighten that feeling. I introduce reds, blues, and ochres as the basic color scheme. I change my mind about the grid behind the figures. The first layer is with Yarka pastels, and then I switch to Rowney and Sennelier soft pastels. With the same three colors I begin work on the faces in darker values."

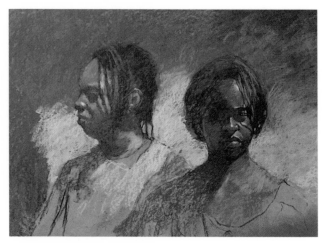

Step 4: "Using an unlimited range of values, I carefully build planes of the faces. I forget about the background for a time as I'm not sure how to use it to underscore the theme of the painting. Along with red, blue, and ochre, I continue to use the umber of the original dry wash. This integrates the colors."

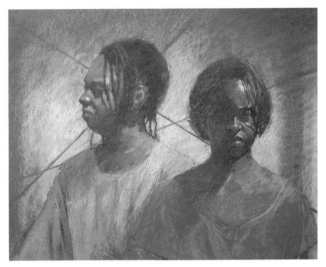

Step 5: "Using charcoal, I redraw some parts of the figures. The background is cooled and I play with the vertical patterns. With a bristle brush I remove some of the pastel as I decide to connect the figures with a grid and light areas behind them."

Step 6: "The same colors are used throughout the painting. The hair is differentiated by the addition of dark reds and blues to the dark hair. Note the expressiveness of the face. Even little details are painted in the areas of the eyes."

TENSION
Claire Miller Hopkins
Pastel on Ersta sanded paper,
22" x 27" (55.9 x 68.6 cm).
Collection of the artist.

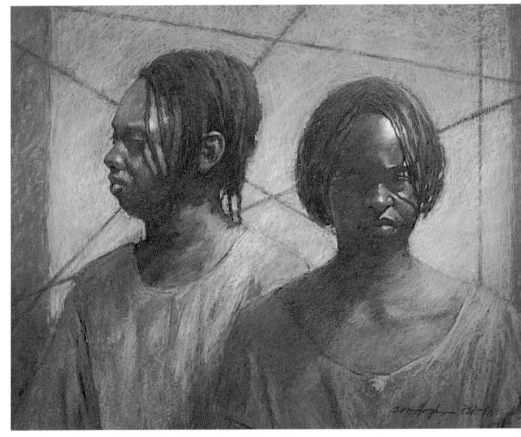

Step 7: "As I finish, portions of the face get lost in shadow and I build light areas to a higher degree of finish. The background is altered again, to evoke an emotional response. The taut strings behind the girls, the vertical bands of shadow enclosing them, the eyes lost in shadow, all help to create a feeling of tension among friends."

Depicting the Love Between Mother and Child

Tom Sierak, a Massachusetts pastelist with a strong sense of composition, creates an incandescent portrait of a young mother holding her baby aloft. It is a familiar scene, which the artist has painted from a viewpoint that makes a compelling design.

As he begins the portrait, Sierak lays out his palette of NuPastels with infinite care. He sketches the composition on Pastelle Deluxe, a paper developed specifically for pastel, which has a fine fibrous, granular coating.

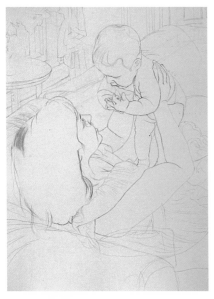

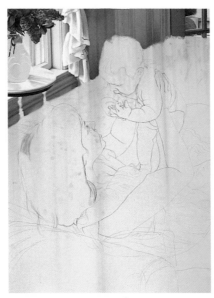

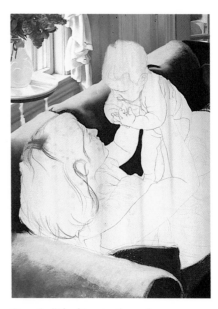

Step 1: "In laying out the composition," says Sierak, "I focus on the strong interaction point where the mother's face and baby's hands are. It becomes the center of attention. To make an exciting composition, I plan to have the figures fill much of the space. A simple outline provides the design and allows me to make changes. With the primary focus (the two figures) in place, I augment the other parts of the pastel and make sure no attention is drawn from the focal point."

Step 2: "Working from upper left to bottom right, from background to foreground, I add color. This method of working prevents pastel residue from coating any areas. It also keeps me from working back into something already finished. Although I use a mahl stick, I find it easier to have an unpainted or underpainted surface beneath my hand. I prefer to block in and refine an area before moving to another section."

Step 3: "Blocking in the sofa completely, I continue with the figures. The sofa provides a strong complement to the skin tones. In such a large area of combining pastels, I wanted to do it all at once to maintain color consistency of the velvety blues. The painting's bottom remains very rough, as it will receive pastel residue."

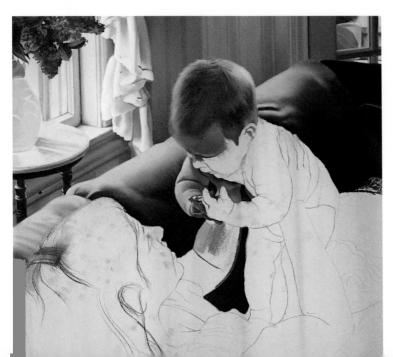

Step 4: "I choose the baby's head to begin working on the figures because it is the highest point. Skin tones are mixed and blocked in."

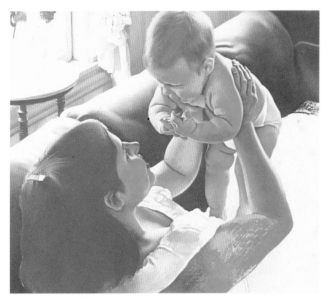

Step 5: "Sections of the mother's hair and clothing are blocked and refined, with the focus on the faces and hands. The painting really comes together at this stage, and extra care is taken in combining, blending, and retouching, and the touch gets lighter and lighter."

Step 6: "The colors and strokes are evident in this detail. If you look carefully, you will be able to see how I weave my colors together so the transitions are subtle and realistic."

Step 7: "The strong interaction between the mother and baby keeps the eye focused on the center. The eye glides easily along the soft and flowing lines. The strong color complements of the blue sofa are offset by the subtle harmonies of the flesh tones, wall, and woodwork. Lilacs provide a touch of nostalgia, and the color is echoed in the mother's dress."

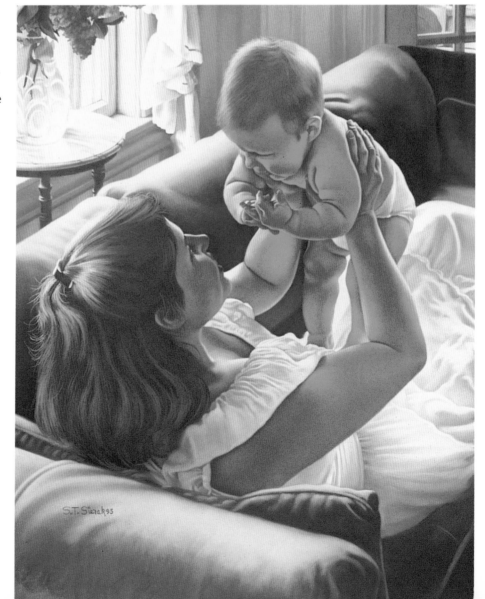

FACE TO FACE
Tom Sierak
Pastel on Pastelle Deluxe paper,
26" x 21½" (66 x 54.6 cm).
Collection of the artist.

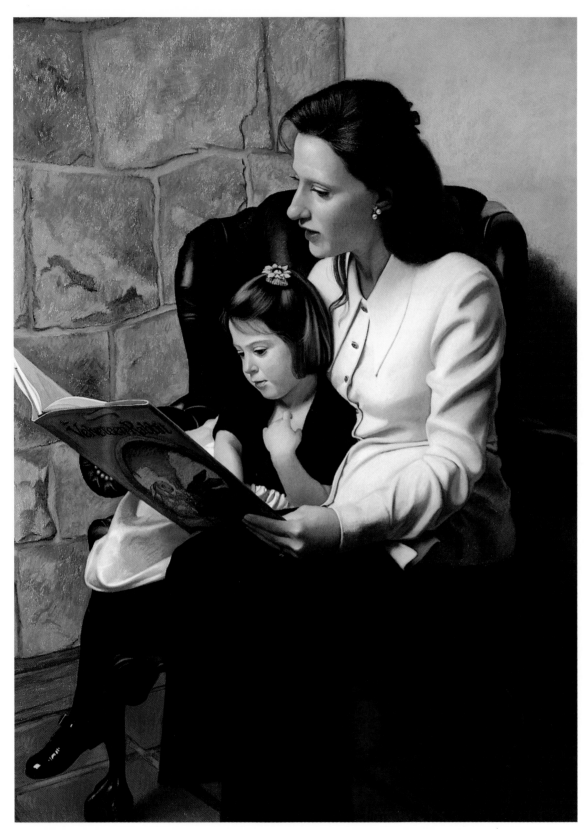

MOTHER AND CHILD
Wende Caporale
Pastel on pastel cloth,
40" x 30" (101.6 x 76.2 cm).
Collection of the artist.

In Wende Caporale's lustrous self-portrait with her daughter, Avignon, the pose conveys the intimacy between the two figures and their delight in a shared pastime. Caporale lays in compelling darks early in the painting. The stone background provides a gauge for the middle values and lights and adds a cool note that is repeated in the flesh colors.

Portrait of a Woman and Her Pet

Although Chloe is a dog, the picture is carefully planned because Lili, who is Tim Gaydos's mother, and her dog will share the center of interest. The challenge is not only to do an interesting painting of Lili but also of her ever-present companion, who is in constant motion. The background is a simple couch with pillows.

The model is lit by a 150-watt floodlight that is placed to her right.

Gaydos has a straightforward method of working: dark to light, layering to achieve color, and using mostly diagonal strokes with varying degrees of pressure. The only change made from the original sketch is to move the model's hand to

Step 1: "Because of the ease of correction," Gaydos explains, "I work in charcoal and carefully work out the proportions of figure and face."

Step 2: "I move the model's hand to form a diagonal and enliven the lower part of the painting. The dog, Chloe, is also worked on. I maintain basic light and dark patterns. The shadow colors are Rembrandt caput mortuum and bluish green. The lights are done with light oxide reds and light oranges. Dark accents are of Rembrandt's darkest shade of Mars violet and Sennelier's darkest indigo. The hair contains many of the same colors, along with ochres and umbers."

Step 3: "While the dog sleeps calmly, I am almost able to finish her. Lili's clothes are developed further."

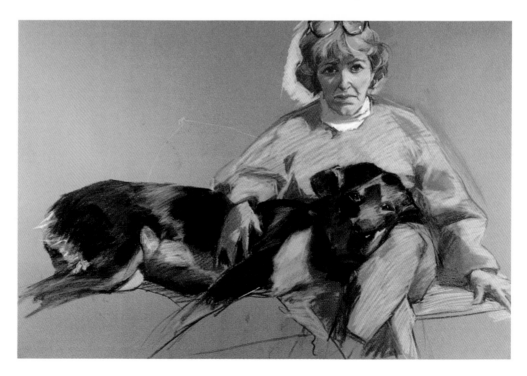

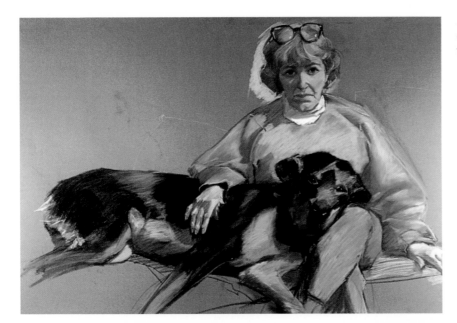

Step 4: "Finishing touches include work on Lili's hands and sweatshirt and the final touches to the dog."

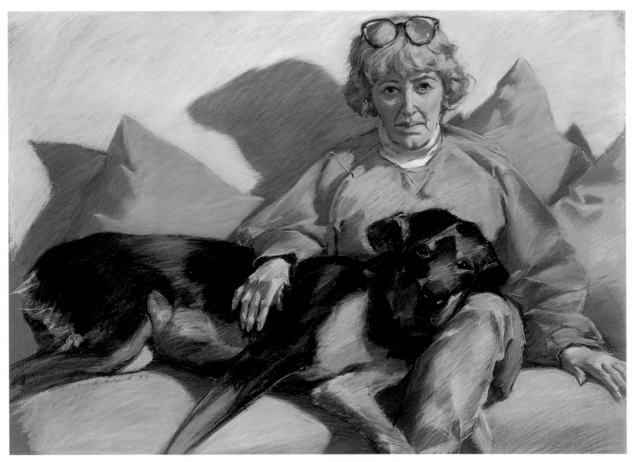

LILI AND CHLOE
Tim Gaydos
Pastel on paper,
29" x 41" (73.7 x 104.1 cm).
Collection of the artist.

Step 5: "I add finishing touches by refining the face, features, and hair. I work on the pillows, Lili's pants, and the background until all the elements are gracefully pulled together."

Painting Groups of Three or More

Portraits of larger groups of figures require even more planning, as the logistics of assembling and posing a group can become a nightmare. Here again, snapshots and preliminary sketches are the artist's greatest aids. It is important to photograph and sketch not only the group but also the individuals and even their features. Studies can be used to work out the problems of positioning the figures. It was a practice of Michelangelo, who was, after all, pretty good at group portraits.

A Three-Figure Portrait

Doug Dawson inadvertently found the subject for this step-by-step portrait while attending rehearsal for a high school musical. "The Pick-a-Little Ladies are a group of high school girls who appeared in these costumes in *The Music Man*," he explains. "When I saw their practice session, I asked them to pose for me."

Step 1: "I block in the composition's big shapes," says Dawson, "with three colors—a light green, violet, and slightly darker orange. I need warm color wherever I want the finished painting to be cool, and cool colors where I want warmth. With a midline on the face and neck, I set up bodily rotation and angles."

Step 2: "Now I block in the background with dark raw umber, which will eventually characterize the finished piece. Originally I used orange in the background to unite the figures—weaving it throughout the painting. I separate the gloved hands into light and shadow sides."

Step 3: "The face is divided into a light side and a shadow side, and I block in the big shadow shape of the dress on the central figure. I reconcile value relationships of the big shapes. Typically I would do this in the first step, but I wanted color to show through. Beginnings affect finished paintings."

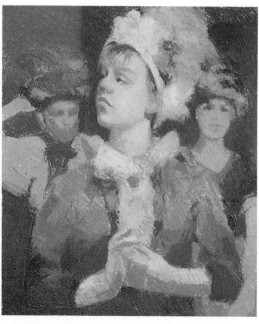

Step 4: "The shapes assume colors meant for finishing. I introduce light warm color into the light flesh tones and cover the length and shadow areas of the dress with midtones of burnt umber. Features are further refined."

Step 5: "I darken the background to draw more attention to the central figure. I continue the process of breaking the face into smaller shapes. As I continue working, I keep the edges soft and the shapes big and simple. I try to keep color cooler than in the central figure."

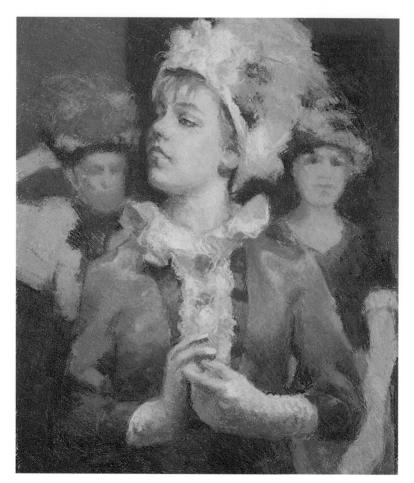

Step 6: "I eliminate the many small spots of board showing through the dark areas of the painting. I check all shapes for hue, value, and intensity, and edges for relative hardness and softness."

THE PICK-A-LITTLE LADIES
Doug Dawson
Pastel on paper,
24" x 20" (61 x 50.8 cm).
Collection of the artist.

A Four-Figure Portrait

Anita Wolff, using La Carte pastel card in light gray, does a mood portrait of four people in Monet's gardens in Giverny. "The day was overcast and drizzling," Wolff recalls, "and everyone was enjoying a restful lunch. The challenge of drawing four people is daunting, because each one is a portrait, and I had to capture the mood and likeness of each person. The most difficult part of making this painting was the placement of the four people. I decided to fill the space and bring the figures to the front of the plane."

Step 1: "I use vine charcoal to establish the drawing on light gray pastel card," says Wolff. "With careful attention to the placement of the figures in relation to the background, I eliminate all but a small amount of background interest."

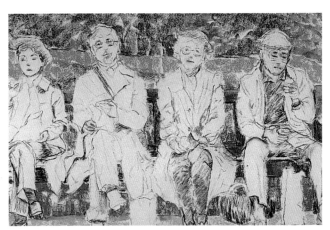

Step 2: "The beginning pastel strokes, in which the dark shapes of the painting are laid down, are placed. The day is overcast, so I start with a cool green-blue color scheme. I use pastels broken into 1-inch pieces, which give me the wider strokes necessary for my style of laying in colors."

Step 3: "This view shows the beginning of the clothing for each figure. I keep the first of these colors very loose and without any detail. I have started placing the cool tones as darks on each face. Also I show the dark tone of the clothing, shoes, and hands and the first middle values of the bench."

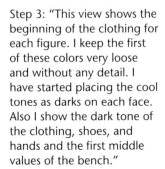

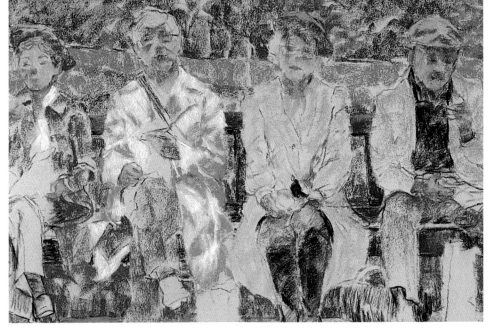

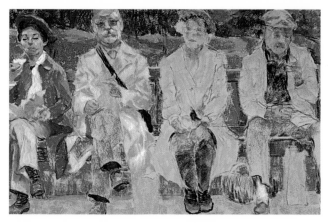

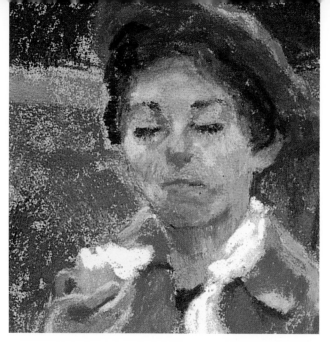

Step 4: "This step shows the application of color moving into the far-left figure for more of the likeness and details. I work on each figure, placing a few details of shoes, hats, and clothing, and I move into stronger colors. I note that the second figure from the right [woman in raincoat] needs to have more angle added to her right arm to avoid a straight, stiff look."

Step 5: "This detail shows the woman on the left side. She is eating an apple, which I feel is shown well in the open, loose way of impressionism. I have caught a good likeness of the lady, my friend Ruth Shannon."

GIVERNY PICNIC
Anita Wolff
Pastel on Sennelier La Carte pastel card, 12¾" x 19½" (32.4 x 49.5 cm). Collection of the artist.

Step 6: "I give a more pleasing turn to the arm of the lady in the blue raincoat. At this time I work through each figure, checking the darks, adding more and finishing with highlights. I complete the man on the right by highlighting his hat and working on the gesture of his right hand. Last-minute touches and decisions add refinement to the pastel."

Wende Caporale

Wende Caporale, working primarily from photographs, draws on Sennelier La Carte pastel card to paint a young woman sitting, with knees drawn up, on the floor. She is reading a book. Distinctive furniture, a sunny interior, and a bouquet of sunflowers in the background are parts of this serene portrait.

Caporale places the model in a strong, diagonal position with backlighting from the window. This is the artist's guest room, painted in a yellow palette,

with many windows and a skylight that casts an overall warmth throughout. "The balancing of the values," Caporale notes, "was the most difficult part of this painting—maintaining the strong pattern while trying to create a soft feeling."

Her working techniques include free-form strokes, scumbling, and broad strokes made with the side of the pastel. Handling the edges with great delicacy imparts a soft, peaceful mood.

 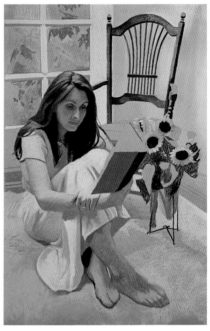

Step 1: "I draw the model with charcoal on middle-tone gray paper," says Caporale, "then lay in the darks with NuPastels, using both warm and cool browns where dark values will eventually lie."

Step 2: "A strong value pattern is established and colors placed all over, with particular emphasis on the head."

Step 3: "The whole range of colors and values is established to achieve the desired effect."

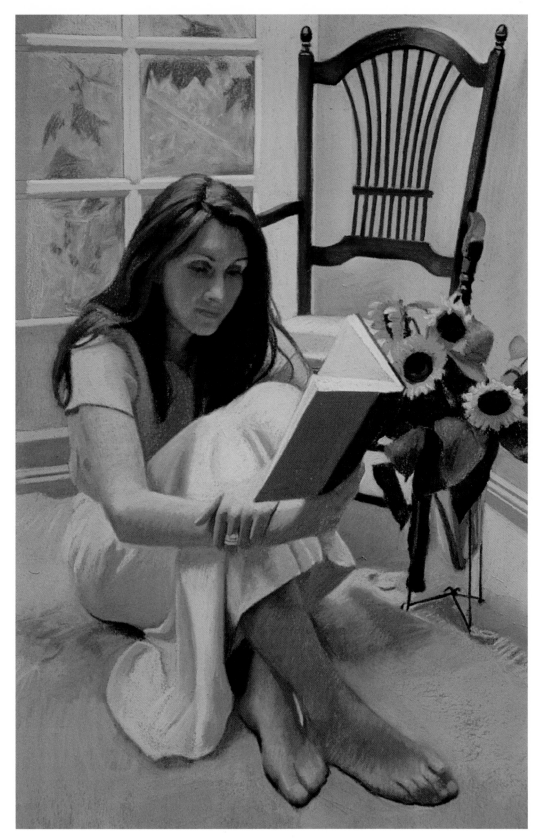

WOMAN IN INTERIOR
Wende Caporale
Pastel on Sennelier
La Carte pastel card,
24" x 20"
(61 x 50.8 cm).
Collection of the artist.

Step 4: "Edges are softened, darks deepened, lights lightened, values
pushed further apart, and color enhanced. I establish the deepest darks
and soften them for harmony."

James Promessi

Jim Promessi works on the smooth side of Canson paper. The model is seated in the dining room of the artist's house, and the furniture is used as part of the picture. The floor and wall are altered for better composition, and a simple background is used. The flowers are Matalija poppies, native to California, which come from Promessi's garden. "I felt that large white flowers with yellow centers would be complimentary to the darks in the figures and the table."

Tatiana is placed at a dining room table in a very natural pose, with her body in three-quarter view and her head almost a full frontal view. The body and head face different directions, with the arms bent at the elbow at different levels and going in opposite directions for interest and variety of pose.

Promessi says, "The most difficult parts of this work occur at the beginning—working out the pose, the composition, and beginning the head and the hands."

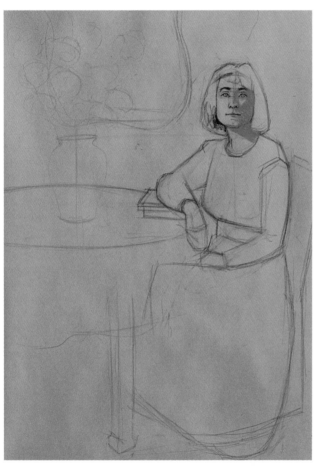

Step 1: "Once the design and composition problems are solved," Promessi explains, "I begin the drawing with charcoal on sand-colored Canson paper. The drawing problems include structure, size, shape, and placement."

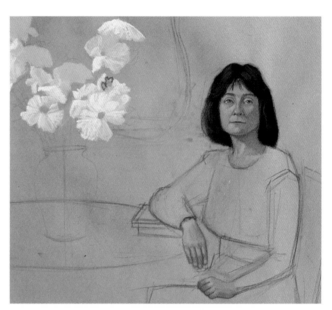

Step 2: "I concentrate on head, hands, and the flowers while they are still fresh. In working with flowers, I use both the actual flowers and information from slides. The flowers, head, and hands demand the most concentration and energy. All parts of the piece will relate back to these important areas."

Step 3: "Well into the piece now, I am trying to unify all the elements so that the pastel works as a whole. I concentrate on color and value changes as I paint with pastel and resolve the drawing."

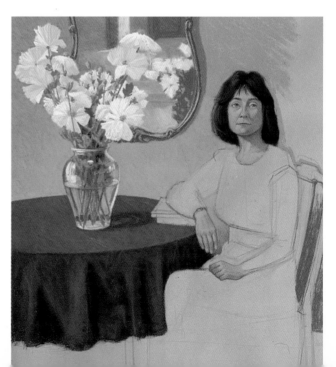

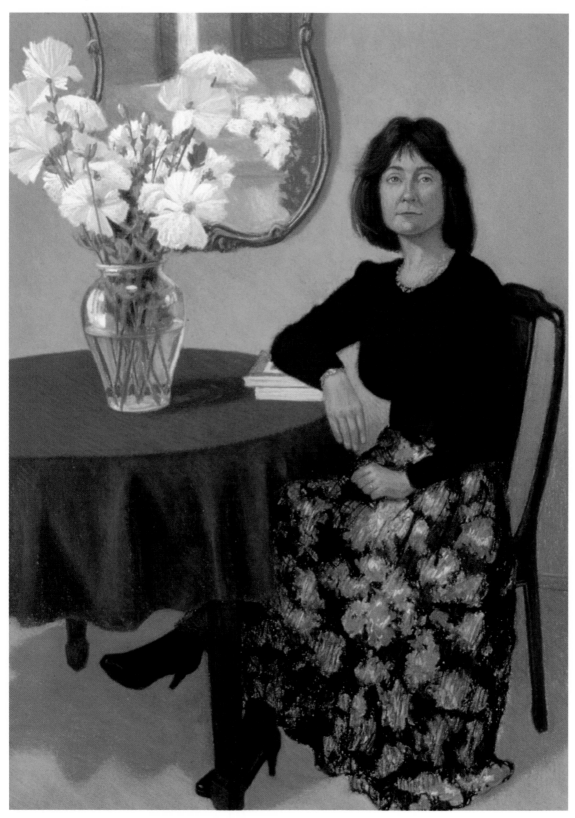

TATIANA WITH
MATALIJAS
James Promessi
Pastel on paper,
32" x 24" (81.3 x 61 cm).
Collection of the artist.

Step 4: "The complex floral skirt was a challenge, but I felt it to be a colorful addition. I feel that the darks of the chair, blouse, and tablecloth compliment the white flowers and light background."

Marbo Barnard

Marbo Barnard uses surroundings and objects in her composition to communicate information about the model, Olive, and the way she lives. The model's husband is a violin maker, and there is a violin showcase in the background. Olive is a mature woman who is looking at a photo album while seated on a swivel chair. The setting is a library with shelves of colorful books. The flowers in this setting are a bouquet of roses of variegated whites and pinks in a white vase.

Marbo Barnard works from several photographs of the model, taken in her home. The support she paints on is Ersta sanded paper bonded to foamcore board.

Step 1: "With a sharpened burnt umber hard pastel," Barnard begins, "I sketch the basic painting on sanded paper, indicating size and placement of the figure in relation to the objects to be included in the painting."

Step 2: "I add dark base colors to the figure, chair, bookcase, and flower vase and start various colors for the flower arrangement."

Step 3: "Not satisfied with the size of the flower vase and style of the flowers, I brush off the entire arrangement. The flower vase is changed to lower the height of the arrangement. I substitute roses to add serenity to the picture. To complete the background, I paint a subdued violin display case."

Step 4: "I complete the model's hair, face, and right arm and finish basic work on the photo album and shadow side of the chair. I lay in shadow on the sweater and basic color on the arm."

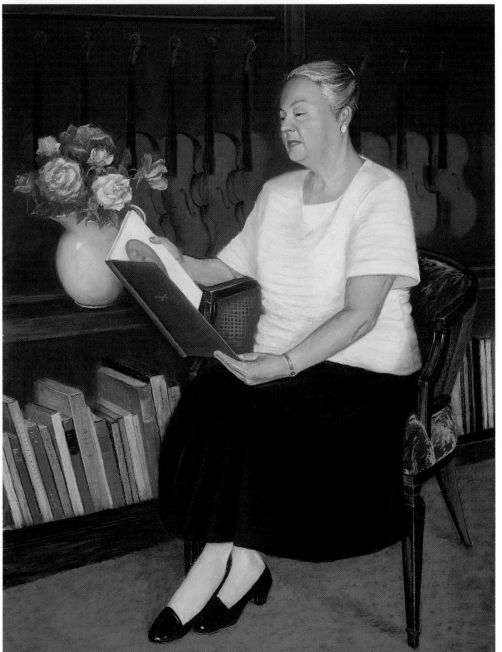

Step 5: "The remainder of the figure, bookcase, chair, and floor is completed. I soften the edge of the sweater and rework some of the lights and shadows as I finish the painting."

OLIVE
Marbo Barnard
Pastel on sanded paper,
26½" x 20" (67.3 x 50.8 cm).
Collection of Mrs. Albert
Muller.

Larry Blovits

Larry Blovits, working from life and backup photographs, paints a luminous white-on-white composition. It is more of a genre painting than a portrait, showing the figure in a contemporary setting reacting to the beauty and aroma of the white flowers.

Blovits covers an antique couch in white and turns the model toward the flowers and the light from the windows, which are carefully controlled by an intricate shade system. He positions her so that the light from the windows will model her face with Rembrandtesque lighting. The most difficult challenge he faces as he works is keeping everything in proportion while developing the color, drawing, and structure. "Searching for all the variations in white," Blovits explains, "I add certain colors while still trying to retain the white-on-white format."

He works in his usual way, using loose hatching and crosshatching to keep the drawing open and flexible, and working from dark to light and simple to complex. Blovits says, "My concern is that all this is the means to an end and, I hope, disappears into the final statement."

Step 1: "With charcoal," says Blovits, "I draw the complete model and interior on Canson Mi-Teintes neutral gray paper. Referring to some photographs I made earlier to record several variations in how the gown drapes, I select the most interesting one. I graph the gown folds because they will change with every sitting—and no model is capable of sitting for hours without a break."

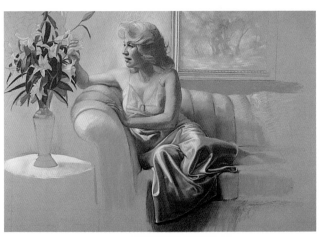

Step 2: "I rough in all the forms and values used in the composition, adding certain elements—a painting, a white frame, and a sheepskin rug—for balance. I intermix Grumbacher, Rembrandt, NuPastel, and Girault pastels to achieve the colors and values I want. Most of the work is focused on the floral arrangement and the model's body. The arrangement of Casablanca lilies requires immediate attention each day because they open and change while I work."

Step 3: "I work and revise the whole composition, bringing the Egyptian vase up to the same level of finish as other elements to have a basis for comparison and evaluation."

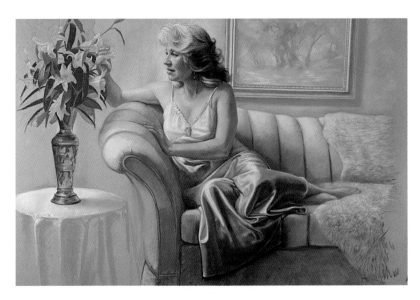

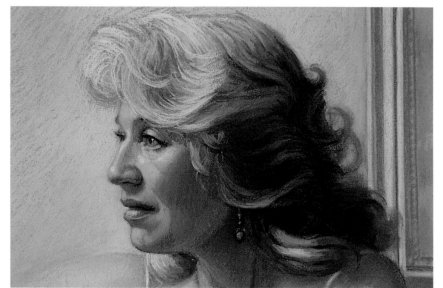

Step 4: "This closeup of the model's face shows the attention paid to light and shade, hair and earring structure, and subtle skin tone variations. My goal in this area is to capture the model's likeness, sensitivity, inner and outer beauty."

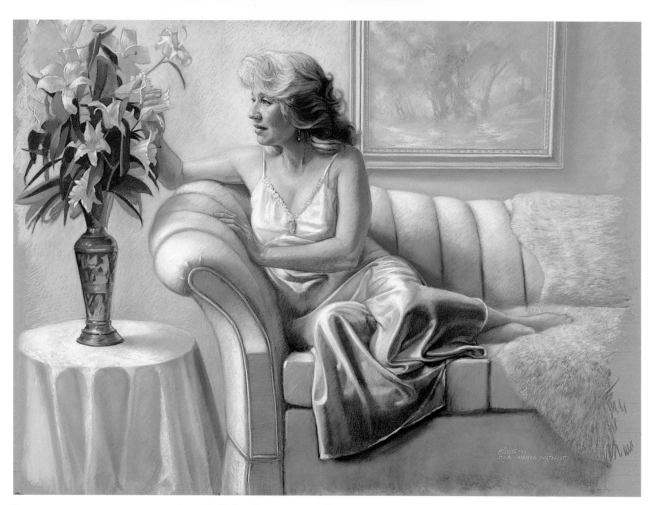

LINDA
Larry Blovits
Pastel on paper,
32" x 40" (81.3 x 101.6 cm).
Collection of the artist.

Step 5: "A few flowers are redrawn to revitalize the weary ones. Finishing touches are added throughout the entire composition, with special attention given to the table, couch, and model's face, body, and gown. The lighting in the finished pastel is carefully reduced in luminosity as it moves from left to right to simulate what really happens with natural light."

Rhoda Yanow

Rhoda Yanow works in her home, using her daughter-in-law for a subject. With Yarka pastels, she works to capture a resemblance and infuse the scene with atmosphere. Yanow's intent is to create a mass of shadow and receding tones from which the figure emerges.

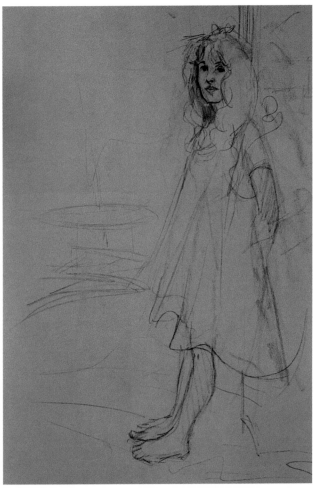

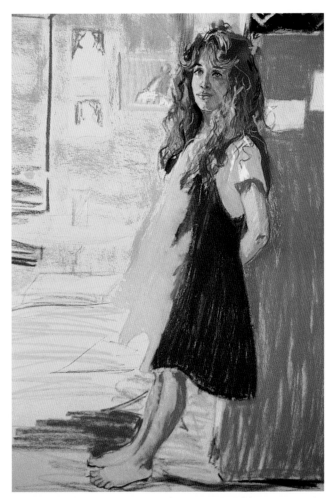

Step 1: "With light emanating from a lamp set up to the left of the model," Yanow explains, "I start a contour drawing for placement. The aim of this particular demo is to place the figure with a vase of flowers somewhere in the background."

Step 2: "At this stage I am working on resemblance. I rough in the background by massing in the shadow. The face, hair, and dress are refined. I tone the background so that as the background recedes, the figure emerges. Randi is the focal point."

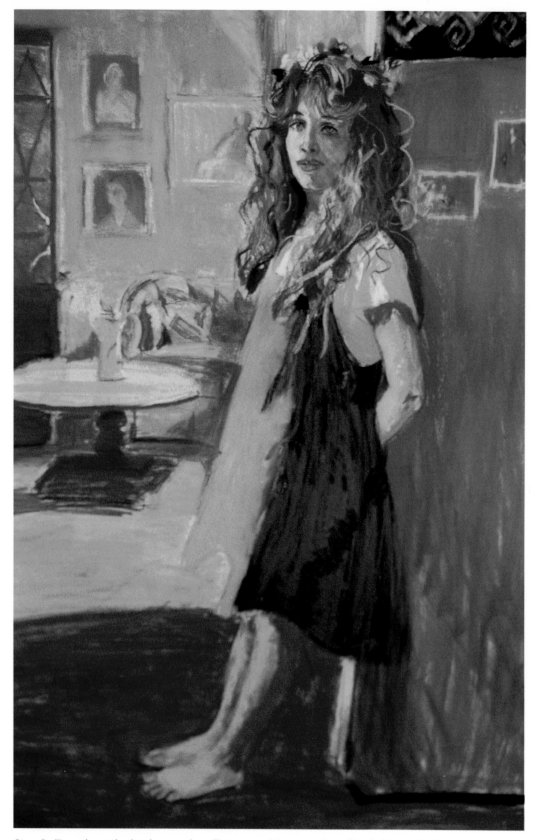

RANDI
Rhoda Yanow
Pastel on paper,
30" x 24"
(76.2 x 61 cm).
Private collection.

Step 3: "I work on the background, pulling everything together. The light on Randi is from the left side. I strengthen the darks, place in lights and highlights, and work a little more to capture the small details."

Tim Gaydos

On oversize Canson Mi-Tientes dark gray paper, working entirely from life, Tim Gaydos paints Donna. With the assignment of incorporating a vase of flowers, Gaydos feels that Donna, an avid gardener, is a good choice as model. He decides to have her arrange flowers. Donna is seated on a stool to elongate the body because Gaydos originally conceived this pose as a standing one.

As the painting progresses, a number of changes take place. The model's hand is repositioned, the shoes are changed, the body is repositioned, and the stool redesigned to entice the viewer's eye upward to the top of the table. Even the bouquet changes as different flowers droop and lose their blooms and have to be replaced with fresh flowers.

Step 2: "After indicating the facial forms with charcoal, I lay in darks with bluish green and caput mortuum on the skin and dark Mars violet and Sennelier indigo for dark accents and the hair."

Step 3: "I lay in lights of English red and light orange for the face and hair. The body and hands are carried to a near finish, and changes seem to be made with every break in posing."

Step 1: "From sketches," says Gaydos, "I lay in the pose in charcoal, taking careful observations and measurements of relations of parts. I continue breaking them down from the largest to the smallest units."

Step 4: "After refining the face and hair, I soften areas of transition and place a purple-gray background around the head. I lay in the table and vase, stool and flowers. The model's hand is moved to a graceful position. The figure is elongated, shoes changed twice, and feet moved to avoid centering them."

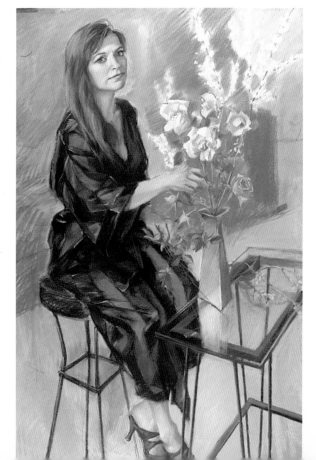

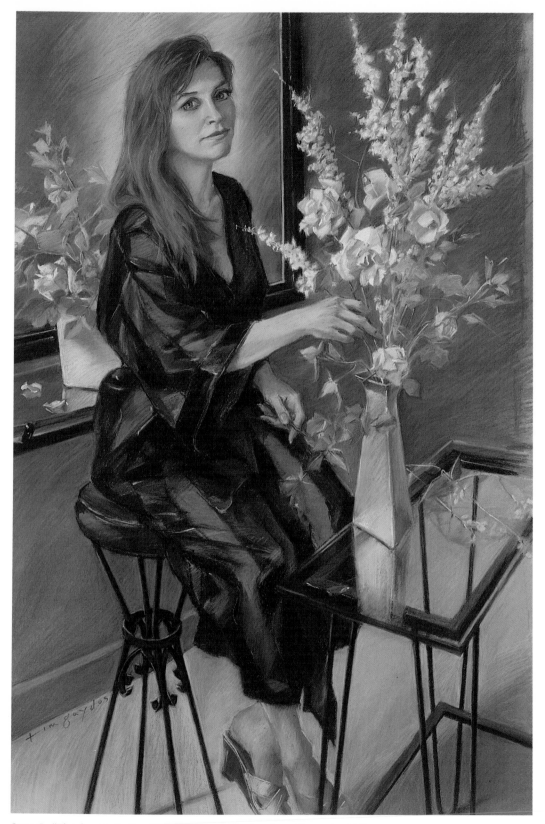

DONNA
Tim Gaydos
Pastel on paper,
42" x 27"
(106.7 x 68.6 cm).
Collection of the artist.

Step 5: "The face is further refined with softening transitions. I add flowers and a mirror behind the figure to give interest to the top of the painting. My intent is to make the top of the painting stronger and to balance the composition and focus more attention on the model's head."

Index

Italics indicate illustrations.